DRAW COMIC BOOK

ACTION

LEE GARBETT

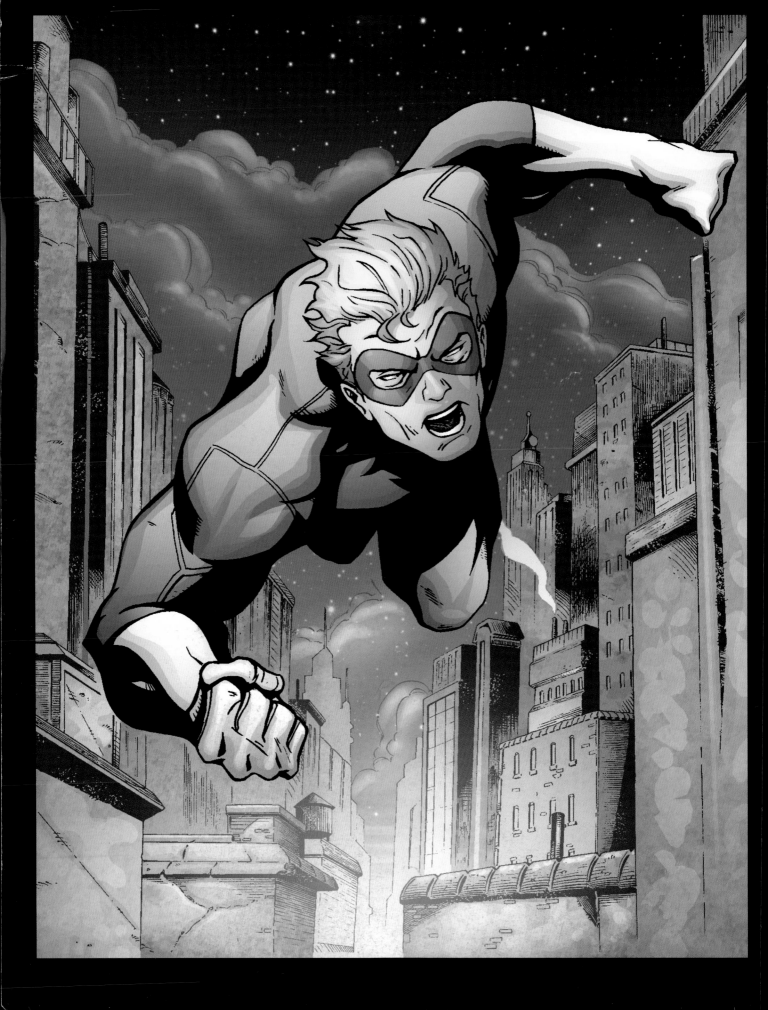

DRAW COMIC BOOK
ACTION

LEE GARBETT

IMPACT

For **Rachael**, **Oscar** and **Brody** – my real-life superheroes.

To **Paul** and **Lorraine** and their secret suitcase of comics. I read them when you were out!

A DAVID & CHARLES BOOK
Text and images © Lee Garbett

David & Charles is an F+W Media Inc. company
4700 East Galbraith Road
Cincinnati, OH 45236

First published in 2010
Reprinted in 2011, 2012, 2013, 2014, 2015
Lee Garbett has asserted his right to be identified as author of this
work in accordance with the Copyright, Designs and Patents Act, 1988.

A catalogue record for this book is available from the British Library.

ISBN-13: 978-1-4403-0813-0 paperback
ISBN-10: 1-4403-0813-6 paperback

Printed in China by RR Donnelley
for David & Charles
Brunel House, Newton Abbot, Devon

Senior Commissioning Editor: Freya Dangerfield
Editor: Emily Pitcher
Senior Designer: Mia Trenoweth
Production Controller: Kelly Smith
Pre Press: Natasha Jorden

David & Charles publish high quality books on a wide range of subjects.
For more great book ideas visit: www.davidandcharles.co.uk

CONTENTS

Hey, fellow comic lovers!

When I was first approached to do a 'how-to' book my immediate thought was 'no way! Who am I to tell people how to draw comics?'.

But then it sort of stuck in my head. After all, I did have some issues with the way some other how-to books had been put together in the past. I'd read a couple and I found them very vague, especially when it came to the figure work. I hated the stick-man that suddenly jumped to a fully rendered figure in three steps. Where's the 'how-to' in that?

If I was going to do a book then it would be nuts and bolts. Basics. Nothing too flash, nothing overly rendered or detailed. Something clear and not daunting to the reader. I wanted a book where it looked like it was possible to see how you got from A to Z.

Not that I was going to do a book, I mean, what did I know about comics?

That's when the initial reaction started to change from being a reason to not do the book to a reason to do it. Maybe, just maybe, as I'm so new to this myself, I could pass on some of the stuff I'd recently learned. Maybe I could help other new artists out there because I was just discovering ways to do this myself. Maybe this was the perfect time to do a how-to book? I most definitely am still learning but what if we sort of learned together? I started to love that idea, it stopped it from being this 'step back and let me show you how it's done' mentality to a 'I'm not sure if this is the right way but it's a way and it's how I've approached it'.

I don't teach anatomy or form in this book, not really. Just the stepping stones. You'll need to look more into that yourself. Study anatomy. Study people. Study movement, mannerisms and body language. Study the way clothes hang. Never stop studying them. Even when you've become the greatest artist in the world! I think an artist is sorta like a shark – if you stop moving forward you die.
The best artists out there are never satisfied with their work and want to do

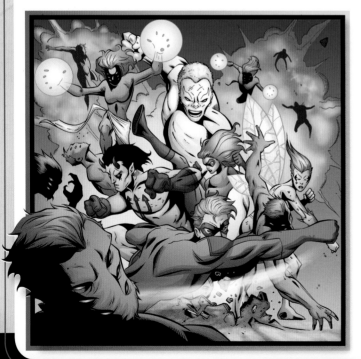

better each time. Yes, it makes for a slightly embarrassed life but it's also what keeps you fresh and relevant. Also, find a style and develop it. You'll naturally move towards a certain approach and while it's good to let your influences guide you to some degree it's your own personality in the work that will make it sing.

Finally, why action? Why focus on that? Well, it's surprisingly not much talked about by a lot of other books out there, yet it's the fundamental key to most mainstream comics. In fact mainstream comics are defined by Action. Sure, we want the day-to-day soap opera of our latest heroes life, but what makes that hero different from those in other media is that he sometimes has to smash a costumed villain through a wall, or rescue a space shuttle, or fight an eight-armed menace.

These are things that make us pick up the books week in, week out. This is why we

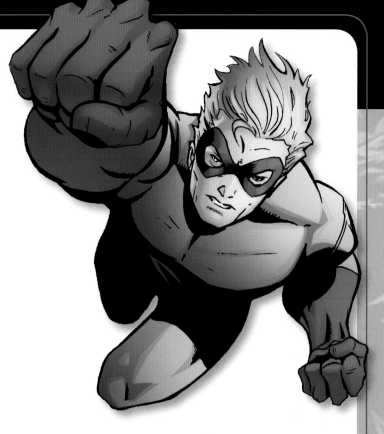

love them and we each have our favourite. And it's also why most mainstream comic artists want to get into the business. Those big battles are just a ton of fun to draw.

So, here we go, time for some ACTION…

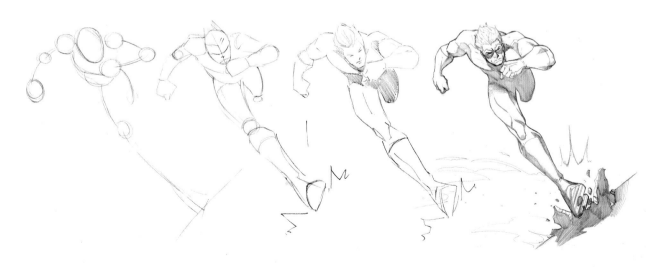

Basic Tools

From your imagination to thumbnails and roughs through to your finished inked piece ready for that splash of colour, you will need some basic media and supports. The variety available is vast, and you should experiment with different kinds until you find what works best for you. Here are the contents of my tool kit for you to use as a guide.

Ruler

Vital for ruling up your panels and creating those awesome city scapes.

Erasers

You can never have too many of these. Putty and plastic erasers are both good, and having more than one on the go means that you can generally find one that is clean and has a nice edge to work that detail.

Mechanical pencil

This pencil is my best friend. I prefer using mechanical pencils to traditional ones, as the fine lines you achieve and the feel of using them is much nicer to me. It's important that you experiment and find what works best for you.

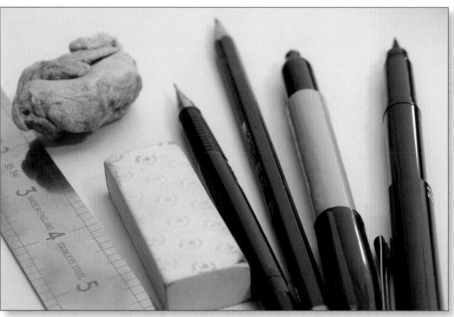

A kneadable putty rubber is soft and easily shaped and has excellent erasing qualities.

Traditional pencils

From HB (hard and pale) to 5B (soft and dark) there is a wide variety to choose from. HB can sometimes be a bit faint, so I tend to use somewhere in between the HB and really dark ones, which I find can be too heavy sometimes. Remember that you ultimately need to remove any trace of pencil, so large areas of dark, soft graphite are not very easy to work with. The softer pencils are good for rough work and thumbnails, but I would recommend using harder graphites in your final work.

Black marker pen

Handy for filling inked pieces and picking out thicker lines.

Inking pens

They should last you for years, but make sure you have a couple of different thicknesses to achieve those graphic lines.

Brush pens

Great for getting realistic, fluid strokes onto the page either at the lightbox stage or inking. They're also nice to rough with.

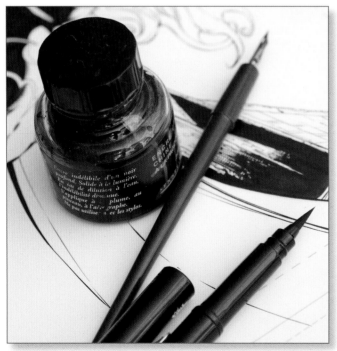

Technical pens produce lines of a precise, regular thickness.

Lightbox

Not vital for the beginner, but essential for the more experienced comic artist. This is an invaluable piece of kit and probably the one object I use the most! It is handy for taking rough pieces forward onto art board, or refining your work onto a clean sheet of paper without having to start again. The old fashioned lightboxes used to be really big, deep and heavy, but you can get much smaller, thinner and lighter ones now that are portable and more comfortable to lean on. See p.102 for more information.

Supports

The paper you use to begin your work doesn't have to be anything special or expensive. Printer cartridge paper at either A4 (US Letter) or A3 (US Tabloid) size is ideal (both in terms of cost and surface texture) for thumbnails and rough work, but when you are moving on to more finished pencils and inks you will need better paper. You can now buy the drawing board that DC Comics and Marvel use either online or in some art stores. This paper is already ruled up and at the size required for the finished printed comic. If you don't want to use this board then as long as you use something with enough pulp and density to absorb the ink stage then that's all that really matters.

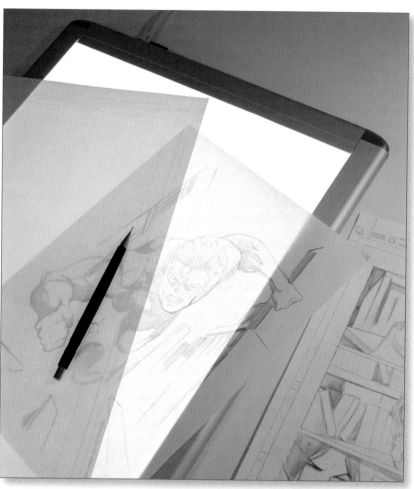

A lightbox is a really handy bit of kit for a comic artist.

It is also worth considering the type of pencil that you use, as this can also affect your paper choice. Mechanical pencils can scratch into some papers, so you need a hard, smooth surface. However, denser boards such as Bristol or watercolour can have a surface texture that it can be really interesting to incorporate into your work. The best thing to do is just buy sheets or pads of lots of different weights and brands and experiment until you find one that you're happy with.

The leads for mechanical pencils come in the same degrees of soft to hard.

Tool Box

Keeping all of your art materials together in one place is a good idea. It means that you always know where your gear is, and can tidy it away each time you finish working. Have a tool box with all of the drawing tools you need and keep it on the drawing board each time you're working.

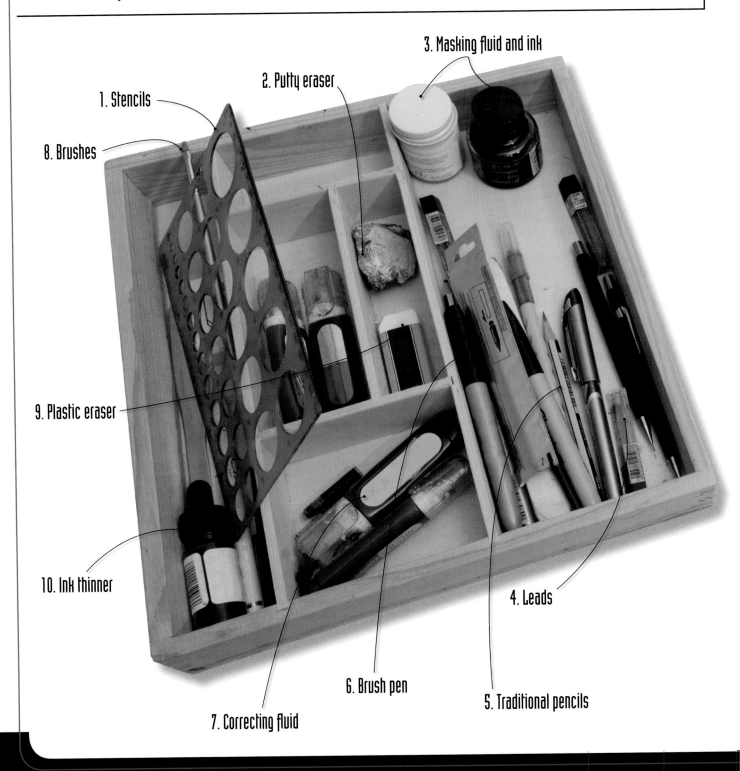

1. Stencils
2. Putty eraser
3. Masking fluid and ink
4. Leads
5. Traditional pencils
6. Brush pen
7. Correcting fluid
8. Brushes
9. Plastic eraser
10. Ink thinner

1. Stencils

You don't need too many of these, but I find this circle one is really useful and speeds up the drawing process.

2. Putty eraser

Good for getting into those tight areas where you need more precision than a big old plastic eraser can give you.

3. Masking fluid and ink

The inker's tools. Cover up areas you don't want to be inked with the masking fluid. It's always handy to have a rag or paper towel close at hand when you're using either of these.

4. Leads

If you choose to work with mechanical pencil you will need to have an array of lead weights for when you need to vary the tone.

5. Traditional pencils

You need these even if you're working mostly with mechanical pencils, as nothing covers an area of shade as well as the side of a wooden pencil, especially if you have a nice long lead exposed. If these are your drawing tools of choice then you will need a variety of hard and soft ones.

6. Brush pen

Useful for when you come to inking and need a fatter, more tapering mark than traditional pens and brushes can achieve. They're also good for picking out shapes and areas that you want to work up in rough thumbnails. Having a variety of colours is a good idea.

7. Correcting fluid

Essential for tidying up your inked piece.

8. Brushes

Ideal for inking work. Brushes produce a more versatile line than pens – a simple variation in how hard you press will produce a thicker or thinner line.

9. Ink thinner

To add variation in tone with your inks. Not essential for beginners, but will come in handy if you start to do a lot of your own inking.

10. Plastic eraser

Some people prefer to work with a harder edge on their eraser, and plastic ones are better for this than the softer putty ones. If you work in mechanical pencil, like I do, sometimes you need to really get an edge into the detail.

Pencil Techniques

What you are drawing dictates the kind of pencil mark that you need to make, as does the area that you're covering – for example, you don't want to outline a figure using cross hatching, but you will almost certainly want to use it for shading. Whatever you're creating, the basis of all of your artwork is pencil drawing, and you will need to practise a range of different techniques to be able to achieve different effects with your pencil.

You can never draw enough, and you can never practise too much. Spend as much time as you can just sketching and coming up with new ways of doing things – not just new camera angles or perspectives, but new ways of rendering objects in your comic panels, such as costumes, weapons, hair and figures. This is where your armoury of pencil marks comes in.

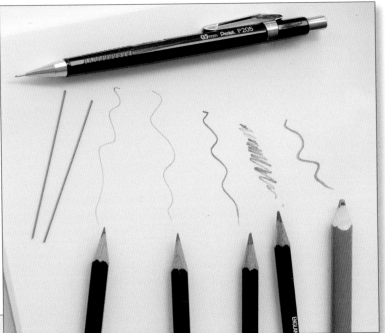

Types of marks

You will need marks for adding tone, highlights, reflections, shading and form, as well as those for creating the basic outlines (see right). Whether you use a mechanical pencil or a traditional one is up to you, but you must experiment as much as you can so that you can find a style that suits you, the art that you're creating and the story that you're telling.

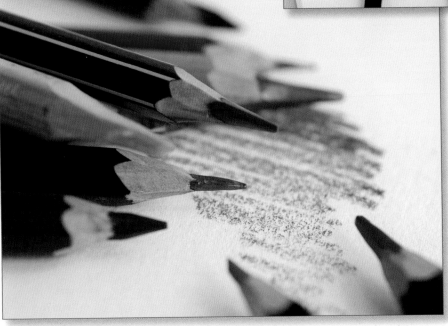

Leads

Use different lead weights, from the very hard and faint H leads that are ideal for outlines, to the soft, dense B leads that provide you with areas of tone (see left). Experiment also with different lengths of lead: if you're using a mechanical pencil a longer lead used with sweeping strokes can create interesting effects, while traditional pencils with a lead sharpened to a flat edge will enable you to colour large areas and really work into the detail.

There are some basic shading techniques that most artists use in their pencil work. Hatching is used for the initial breaking into form, where you move from your flat outline and begin to create a three-dimensional figure in certain lighting scenarios. Having fewer hatching lines and further apart creates the effect of graduated shading, coming out of the dense areas and into more light, as seen below.

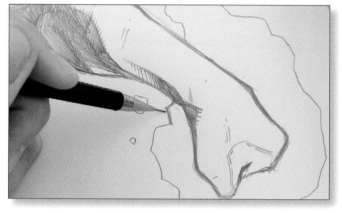

Cross hatching is useful for areas of graduated shading, moving from really strong darks into lights. Cross hatching is also useful for creating an area of grey, rather than the solid black that you would achieve with the side of a pencil, for example. This is particularly useful when you're inking and can't vary the weight of the black. Cross hatching can be used to add subtlety and varied tone (see below), and you can vary the density simply by tweaking the number and proximity of lines that you apply.

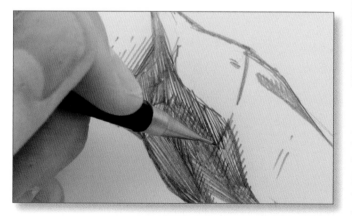

General shading is best done with a slightly used lead (see above right) with a mechanical pencil (a sharp edge provides too sharp a line), and a blunted one on a traditional pencil. To achieve the edge that you need either work the pencil on a piece of scrap paper until it's at the weight you want, or work a traditional pencil with a piece of sand- or glasspaper. However you decide to do it, it is always a good idea to test your mark density on a separate piece of paper before you add it to your finished art.

An eraser is an essential part of your tool kit, both for correcting mistakes and for adding highlights to dense shaded areas if you're working in tight pencils. You can either use a kneadable, soft putty eraser or a plastic one (see below) – the choice is yours. Putty erasers can be worked up into a point and can be really handy for erasing in the detail sections. Some artists prefer the hard edge of a plastic eraser, so you must choose whatever works for your piece.

If you are a comic artist who is having their work inked by someone else, you need to decide whether you're going to work with the lights and darks, or simply use outlines and mark the darks with an 'x'. There is no right or wrong way, and it is largely down to personal choice. If you have a lot of work to do then using the 'x' method can save time, but some artists like to see how the shading is working in an image, and what it's actually going to look like when it's inked.

It will be hard to use the 'x' method when you're just starting out, but it may be something to consider as you get more experienced. It is also worth remembering that areas of dense pencil will be hard to ink over as the ink sometimes runs over the sheen of the pencil mark. This means that whoever is inking your piece will probably need to erase the pencil first.

Digital Tools

You don't need lots of fancy, expensive equipment to start drawing comics, but as you grow in experience and get more work you will find that you start needing some modern-day digital assistance.

Computer

Whether to buy a Mac or PC is a decision that only you can make. Most of the industry uses Macs, but they do tend to be more expensive. Whatever computer you choose make sure it has plenty of memory to be able to handle your digital portfolio, and that the screen is a decent one that represents colours accurately and shows enough detail.

Drawing tablet

Not essential, but very handy when you're doing your own colouring. I use a Wacom tablet, but there are other less expensive ones available.

Software

The most commonly used colouring software is Adobe Photoshop, so it's a good idea to get hold of that. Corel Painter is a similar, cheaper programme that will suffice when you're just setting out.

Hardware

A flatbed scanner is essential when you want to take your work into digital and start colouring. Get one that has as big a scan bed as you can afford – A3 (US Tabloid) are ideal but can be more expensive than A4 (US Letter) ones. You can work with the smaller ones, but find that you will spend a lot of time stitching the different parts of your image together to make it complete again. A printer is also handy for printing off proofs that you are emailed, and also for keeping hard copy records of your work.

Proportion: Male

Comic book action is focused on the figure – that is where the story is told. As a comic artist you need to really hone your figure drawing skills, so that you can draw them accurately, quickly and repeatedly.

The stick figure should be really basic and quick to do. Circles represent joint locations and facial features are marked with a cross.

Creating a side profile is a good way of practising. Pay particular attention to the shape of the head in profile and the shoulder location. Profile camera angles are generally the least impactful, but they're good for working out proportion.

You can see how the different parts of the body are represented with completely different shapes when in profile.

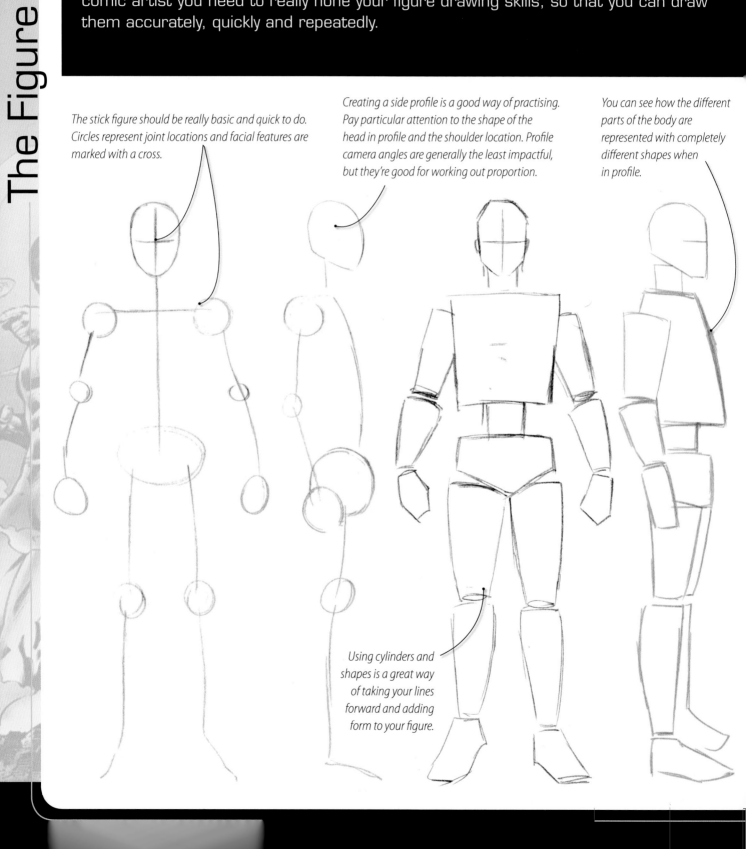

Using cylinders and shapes is a great way of taking your lines forward and adding form to your figure.

There aren't really any hard and fast rules about figure proportion in comic art. Some people use one theory of there being seven heads in a human body, while others are just able to draw the proportions correctly first time. Experience will enable you to do it more instinctively, but use the seven heads idea when you're setting out if it helps you.

The only things that you really need to remember are that if we're dealing with superheroes, they need to have superheroic proportions. These often vary from character to character, but they generally have wider shoulders, bigger heads and longer legs and arms.

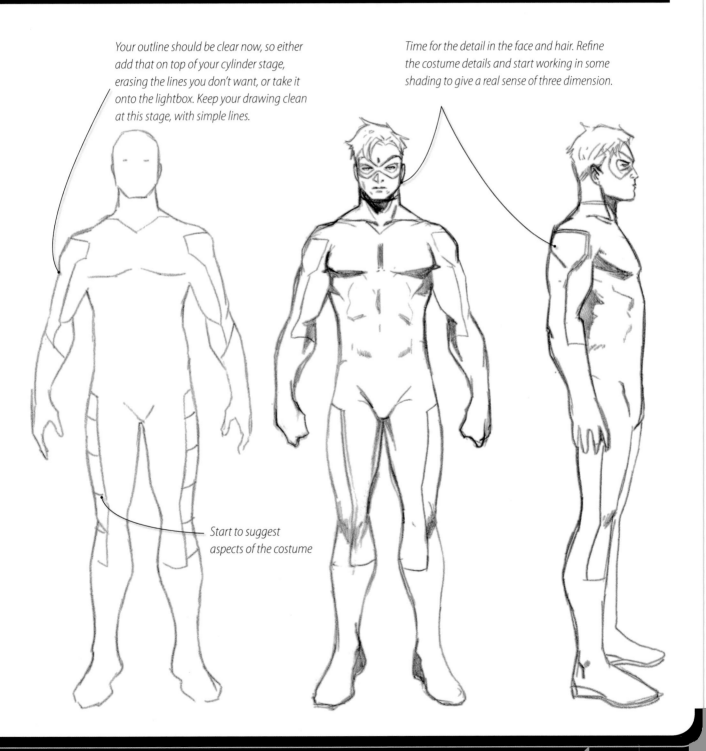

Your outline should be clear now, so either add that on top of your cylinder stage, erasing the lines you don't want, or take it onto the lightbox. Keep your drawing clean at this stage, with simple lines.

Time for the detail in the face and hair. Refine the costume details and start working in some shading to give a real sense of three dimension.

Start to suggest aspects of the costume

Proportion: Female

Tracing can help you to get used to human form and the way lines curve and shape the figure. Traced figures often look static, however, so you will need to move on and start creating your own figures as soon as you can. References are of course handy – and sometimes essential – but there comes a point when you have to leave the reference because your drawing just starts to look ridiculous. You can't find a real-life reference for a superhero, and you can't just stick

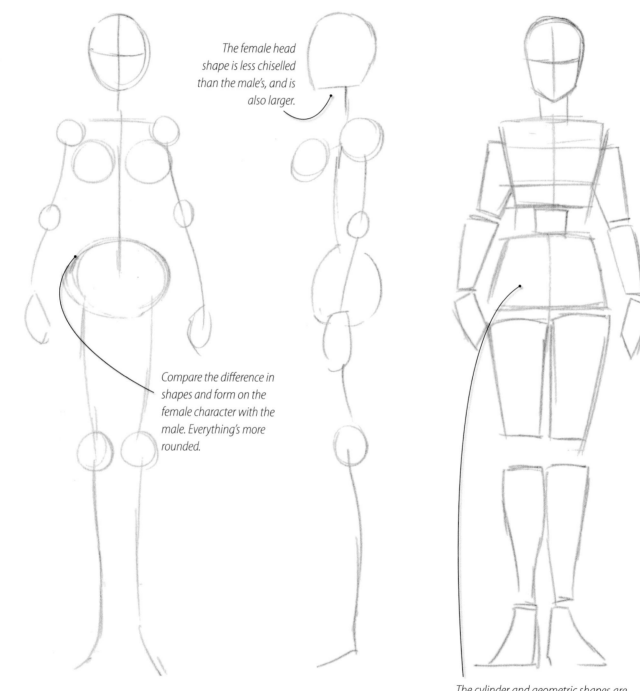

The female head shape is less chiselled than the male's, and is also larger.

Compare the difference in shapes and form on the female character with the male. Everything's more rounded.

The cylinder and geometric shapes are smaller and more angled, with more of an emphasis on the triangular shape.

a superhero costume on a referenced character. Learn to relish the move away from the reference and see it as the opportunity to really spark your imagination. You can of course go with grotesque proportions if that's your thing, but if it's not then you need to have a bit more elegance and be more refined with the female figure. Just remember that whoever looks at your character has to instantly know who or what it is.

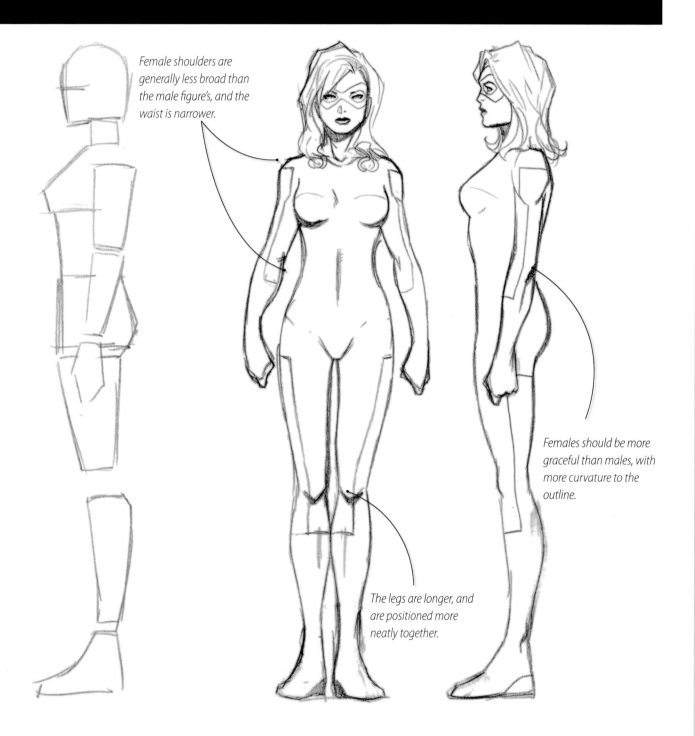

Female shoulders are generally less broad than the male figure's, and the waist is narrower.

Females should be more graceful than males, with more curvature to the outline.

The legs are longer, and are positioned more neatly together.

Stick Figures

When you're using stick figures as the basis of your drawing it's important to use the stage to help you not only work out the composition of your panel, but also the form of your figure.

Don't just draw a figure where you want it to be – think about the lines of the body, the fluidity of the movement and, most important of all, think about what the spine is doing and how it looks. A lot of people make the mistake of just drawing the spine as a straight line, but if you study the human body in action you should be able to see a clear, flowing line from the top of the head right to the tip of the body. Getting the spine right is key to making your images really work.

FLYING

Nothing on the human body is ever straight, especially if it's load-bearing. Having the bends and flexes of the figure correct is essential to ensure that your image doesn't look static.

CROUCHING

An important pose to observe when you're just getting going. See how the shape of the torso changes, and the actual parts that you see are different than you would expect. It's vital to get the upper, bent leg bearing the weight correctly under the body.

LAUNCHING AT THE READER

A really good pose to get the reader into the action. Flying scenes are more impactful if it feels as though the figure is coming right at you, and is about to soar past. Think about the key shapes of the torso but, more importantly, what will happen to the legs behind. Remember that it's better to have each leg doing something different.

KICKING

You have to represent balance and weight correctly, and this is never more important than when you're drawing a kicking figure. Think about the centre of gravity and where the focus of the weight is going to be. Use references to see how the muscles and joints in the whole body respond not only to bearing the weight of standing on one leg, but also the sheer force of kicking out with the other.

LEAPING

Using stick figures is a good way of working out your foreshortening on difficult poses, such as this one. Do the pose yourself in the mirror, and draw as many quick figures as you need to work it out – you need to be confident that it's going to work before you take the time to do a finished pencil piece.

PUNCHING

Action always has to be dynamic, but it can easily become static. When you're drawing impact, such as someone punching, it's important to show the moment just before or just after the impact, rather than the actual hit. This is because you then have maximum power, energy and force and can really show the effort that's gone into the impact. If you show the punch itself it looks like someone's being touched on the nose, and you won't be able to show the response of the victim to the punch, which also helps you to create a sense of action.

LUNGING

Think about the shapes the figure is making with the movement and keep them graceful and realistic. Think also about where the eyes are going to be looking, and how that might affect the shape of the head. It's amazing how different the head can look from various angles, and it has to be angled to match the gaze.

SWINGING

It is simple enough to show movement in a finished piece by using speedlines, flowing hair and capes and so on, but you have to get the initial movement in right at the beginning stage – you can't create a static figure and then make it move. To do this you have to really think about how the body would respond to what you're making the character do. How the legs and arms would bend under the weight or force, and how they would stretch to provide balance.

RUNNING

Another opportunity to get the figure coming right at the reader. Again, think about where the legs and lower torso will be and what we can actually see. Focusing the eyes on the reader in a shot like this really helps to draw you in to the action.

The Head

Drawing the face is an essential skill that a comic artist has to have in their repertoire. Not only do you have to be able to draw faces realistically, but you have to be able to draw them so that they can be recognized each and every time you create them. Make sure that you have done enough character development work and read enough of your script to feel that you really know who the character is. As strange as that sounds, it will really help you to draw them and tell the story.

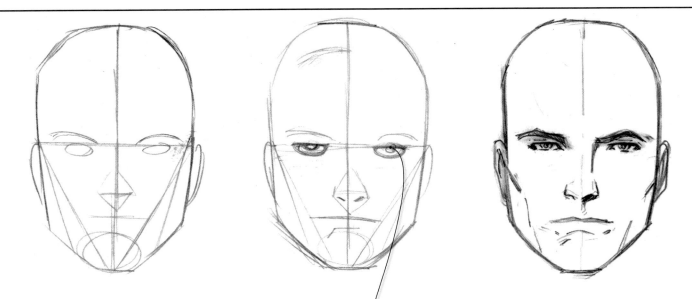

There are some rules about drawing faces and heads. The most important thing is the feature placement – the top of the ears should be level with the top of the eyes, the eyes should be one eye-width apart, and the line down the face should pass through the middle of the nose mouth and chin.

There are so many hairstyles to choose from that you might need to play around with a few of the options. Magazines and online are a good source of reference, but make sure you don't copy anything directly or infringe someone's copyright. Remember that you will have to draw the figure more than once, so creating an elaborate hairdo might look good, but probably isn't practical.

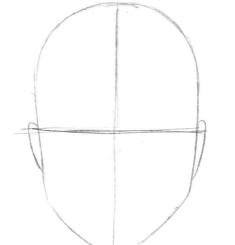
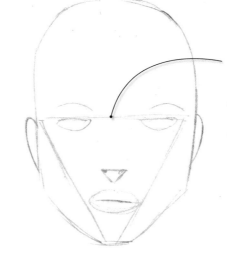

You can use the rules for facial feature placement for the basic elements, but you have to tweak them to make them unique to that character and personal.

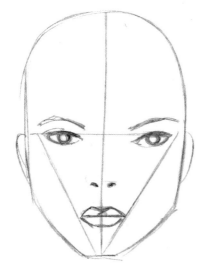
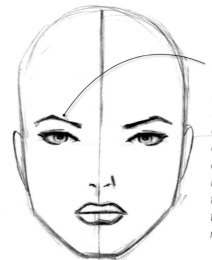

Many comic artists are worried about being able to draw recognizable characters, but you will be fine. Practise drawing the same person over and over until you're completely happy with your rendering, are confident that you are familiar with them and can render them recognizably everytime.

Long hair can be a good storytelling tool, especially for adding a sense of movement when the character's flying or running.

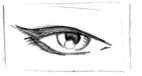
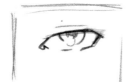

Look in the mirror and see how pulling different expressions affects the shape of your eyes and nose. Check your references to see how different light sources reflect in the eyes.

Hands and Feet

We might not generally think of our hands and feet as important tools for communicating, but we can learn a great deal about someone from a tightly clenched fist, or a tapping foot. Comic artists need to use every storytelling tool available, and these are just too vital to ignore.

HANDS

You can get a lot of emotion into a character's hands – the grip, the placement, what else they are shown with, for example. It is a good idea to always try to get the hands into a shot, especially if you have a close-up of someone's face. Acting in comics has to be more dramatic than films because it's a static medium, so in order to get the drama across you always have to go to the extreme with facial expressions and body language in order to tell the story, make it convincing and, most of all, make it captivating.

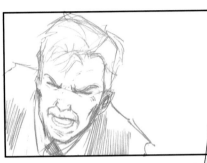
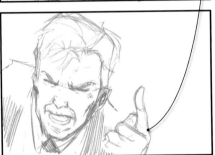

This man would still look angry and menacing, but putting his pointing finger in brings a whole new level of aggression.

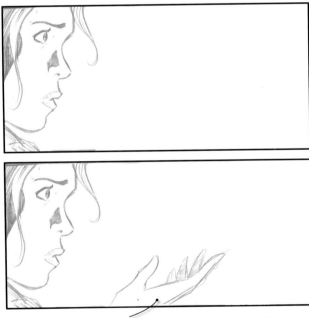

A pleading face becomes even more desperate with the addition of a hand.

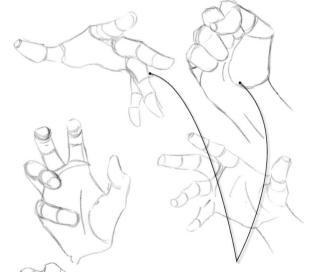

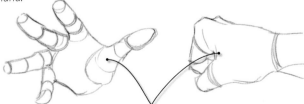

Take lots of pictures with your phone or camera showing your hand in different poses, and use as references. Make sure that you show them from lots of possible angles.

Think about how we use our hands to stress what we're saying. Watch films and television programmes to see how they are a vital communication tool and to really observe how they're used.

FEET

The important thing with feet is to make sure that you have the flex and weight bearing correct, otherwise they will not be believable. Feet also have a tendency to ground a character and take away motion, so always consider if you can just show one foot on the ground and the other in the air, or obscured behind the body. The most impactful is to have the other foot doing something dynamic, such as being yanked out of some rubble, but that's not always going to be possible so you will need to think of other ways of keeping the action alive.

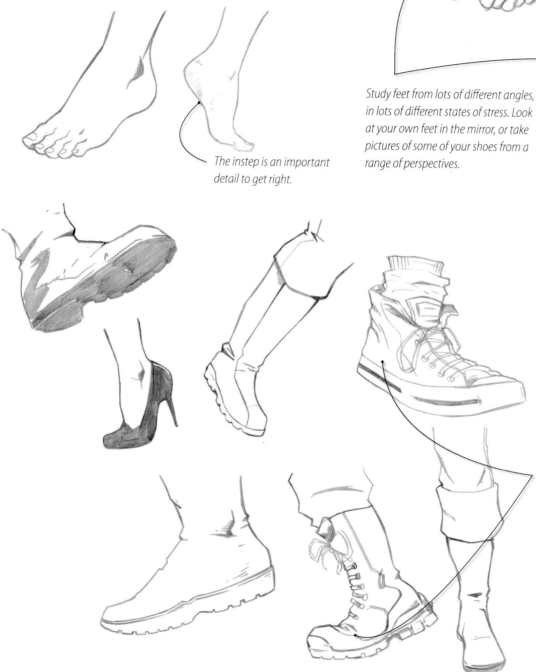

Study feet from lots of different angles, in lots of different states of stress. Look at your own feet in the mirror, or take pictures of some of your shoes from a range of perspectives.

The instep is an important detail to get right.

Research lots of different types of footwear and practise rendering them. Study particularly how the material (fabric or leather) responds to weight, flexing, twisting and being at rest. It is these details that really sell the story.

Shading

Shading adds form to your work and is the first step to creating a three-dimensional figure. Introduce shading to your drawing when you have finished the outline, and keep adding it until you're happy with how your picture is looking.

Think it through

What kind of paper you work on is an important decision that will affect your shading. Textured paper can add an interesting dynamic to your work, but if you like tight lines and use a mechanical pencil then you will need smooth board. If your style is looser then a rougher, more textured board is best. Soft pencil, which is perfect for shading, is great when used on rough board.

Whether you use hatching or cross hatching (see p. 10), stark black and whites or lighter, more textured lines, the fundamental point of shading is showing the transition from areas of shade to light, and you have to be able to do this, whatever your style, paper or tool of choice.

Begin by outlining the shaded area with your drawing pencil. At this point you can either mark with an 'x' or continue the shading yourself.

Fill the area to be shaded with general strokes, and then start to pick out the tone around it using hatching.

Start working around the area adding more tone and three dimension. Remember that you have to be able to show moving from areas of tone to areas of light. Think also about the curvature created by muscles and how that will respond to the light.

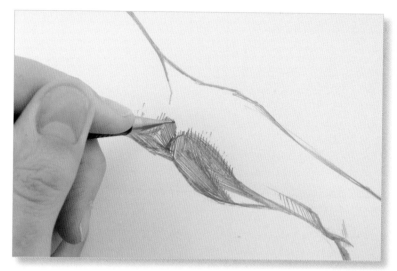

Start working on the shading around where you've been working. Use hatching lines in a variety of directions to show where the form is changing.

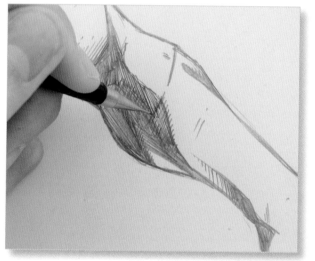

Study your own arm and look how the light hits it. Really look at all of the lines and areas of tone and form that are visible, and start working this into your drawing.

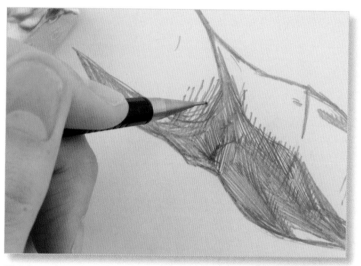

Finish working into the areas of shade. Stand back and check that you're happy with it.

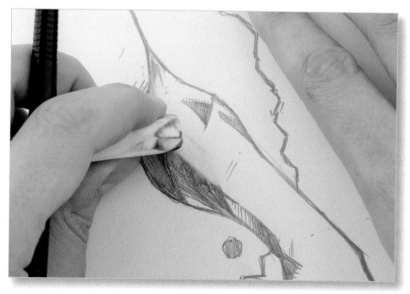

Use your eraser to remove any lines you're not happy with, or if you think the shaded area has got too large. Your eraser is also a useful tool for making the blending from dark to light a bit more subtle.

Foreshortening

Comic action needs to be dynamic and three-dimensional, and foreshortening is an essential tool to help you achieve this. It can be a tricky skill to master, but you just won't have the impact that you need in your panels unless you use it.

Foreshortening is when you display the parts of your drawing that are nearer the viewer as larger than the rest of the drawing. You can foreshorten anything – weapons, anatomy parts or any foreground object, but you have to get the perspective right, otherwise it just won't look right. Foreshortening objects creates impact and really pulls the viewer in to the thick of the action. Don't be afraid to revert to your stick and cylinder figures to perfect your foreshortened image – you have to really work out what's going to be visible and what's not, and make sure that anything that is enlarged is to scale to be believable.

Having the smoking gun punching out of the foreground of this shot tells an impactful story. The position and perspective lines provided by the gun also help to draw the reader's eye into the image, and then to the face of the person holding it.

Use your mirror to study how the foreground arm and fist would look.

Foreshortening also helps to create a sense of movement. If every part of this character was at the same size it would not only be a flat, lifeless shot, but it also wouldn't create the illusion of movement.

This camera angle and fore-shortened foot have put all of the energy into the kick, rather than the face. It is the kick that is the story here, so having it as the focal point is an effective way of showing the action.

If you focus on getting the foreshortened parts of an image spot on then it can save you time by not having to create the level of detail in the rest of the image that's in the background. Compare the detail with the fists and arms in the fore- and background here.

Foreshortening a face can be a really good way to tell a story. Facial expressions are key to portraying what's happening, and having the face as the focal point of an image can be really powerful. It also gives you the chance to get some real detail into the features and expressions of the character.

We know that portraying movement is about weight, and this is where foreshortening can help. The reader is in no doubt that there is motion in this image, and that the weight is on the leading foot.

Facial Expressions

This is one of the really fun parts of comic art. The face is one of the most important storytelling devices, and you have to use it to get across the emotions that the script is calling for.

How to do it

To draw a good facial expression you have to put yourself in the character's position and act the emotion – imagine how that character is feeling and what face you would pull if you felt like that. It's a good idea to have done lots of character development work beforehand so that you are familiar with who you're drawing and can really get under their skin.

Remember that you may have to draw the same person pulling lots of different faces over the panels in the comic, so it is a good idea to take some time out and practise drawing lots of different expressions on the same face and make sure that they're still instantly recognizable as that character. Key features, such as hair styles and lines, jaw lines, eyebrows and noses, are good anchor points for the face and help with identifying the character, but remember that these may need to move according to the face that's being pulled.

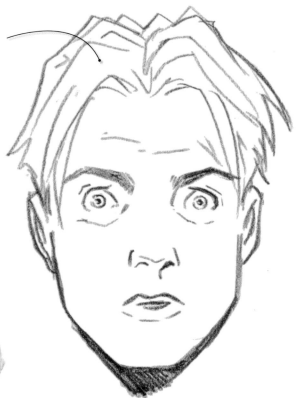

The eyes are the most important aspect of the face where storytelling is concerned. Their shape tells you a lot about what's happening and how that character is feeling. Remember that different expressions use different parts of the face, so a shocked face is going to have forehead creases and lines beneath the eye.

Sideways glances are sly, edgy and alert. Think about how the eyebrows respond with this face, and really hone the chiselled features of the jaw and nose. Do these expressions in the mirror to get them looking really natural and realistic.

Having your character looking up naturally makes the reader look up as well, to see what is happening. This camera angle changes the hair shape and also the ears, as well as putting the focus on the mouth and chin.

Female faces generally have less lines than male faces. The eyebrow shapes are also different, and the jaw- and mouthline are generally finer.

Shouting tenses most of the muscles in the face and so changes the features quite drastically. Lots of lines are needed to really show this aggression, along with narrowed eyes and raised eyebrows.

Basic Action: Running

As a comic artist you don't have any say in what the characters are actually doing – the script dictates the action. You do have some say over how to portray that action, and the camera angle to use that best tells the story. Running, swinging, flying, leaping, kicking and punching are all standard action poses, and you have to choose the most effective angle to show them from. Over the course of one comic you will have to draw these poses repeatedly, so the more angles to show the action from that you have in your portfolio, the better. Here are some basic poses and angles to get you started.

Think about the spine. Drawing it at this stage, as simply as this, will help you to build the rest of the body around it. Remember it's never straight, and its function is to support the movement of the body.

Think carefully about your camera angle and what will be visible and where. You have to get these things right at this early stage.

1 Get the foundation lines of your figure down on the page. Think about the shapes the figure will be making, and keep your lines fluid and quick.

2 Add in the joints as simple circles. Think about how they will react under pressure, and how the limbs running off them will be positioned.

Angling the head down shifts the features down on the face and reveals more of the head. It also adds a sense of determination to the character.

3 Start to bulk your figure out using cylinders to add form. Erase any lines you don't want to keep the drawing tidy.

Think about where the weight focus is going to be and how you're going to emphasize that. Here it's on the right (leading leg) and the left arm, with the weight forward. Thinking about these and getting the rendering of them right will help to ensure that your image is not static.

Think about what's happening as the figure's foot hits the ground, and start to pencil in some impact. This heightens the sense of movement and power.

4 Start to think about the facial features. What's happening in the story? How is the character feeling? Mark these in very simply until you're happy with them.

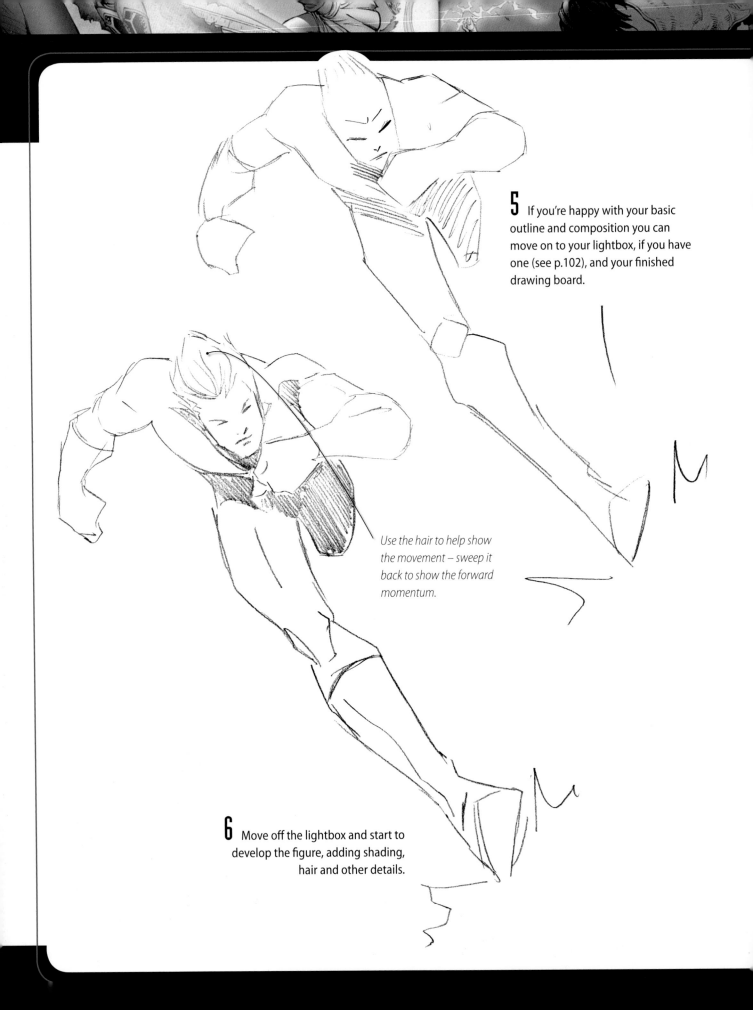

5 If you're happy with your basic outline and composition you can move on to your lightbox, if you have one (see p.102), and your finished drawing board.

Use the hair to help show the movement – sweep it back to show the forward momentum.

6 Move off the lightbox and start to develop the figure, adding shading, hair and other details.

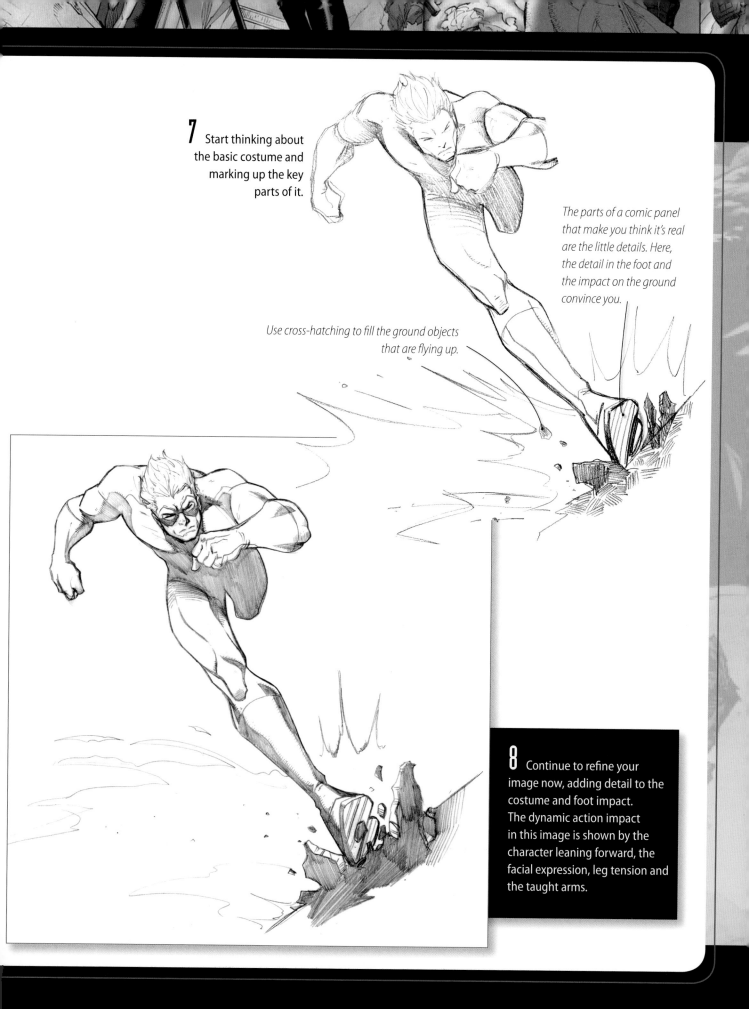

7 Start thinking about the basic costume and marking up the key parts of it.

The parts of a comic panel that make you think it's real are the little details. Here, the detail in the foot and the impact on the ground convince you.

Use cross-hatching to fill the ground objects that are flying up.

8 Continue to refine your image now, adding detail to the costume and foot impact. The dynamic action impact in this image is shown by the character leaning forward, the facial expression, leg tension and the taught arms.

Basic Action: Swinging

To be able to show a superhero swing into battle is all part of the job for a comic artist. Where you want to show them from – above, so that the reader can see what they're swinging on and the action around them; from front-on as they swing towards the reader; or from below to illustrate the height – is up to you. Look at your script and see what the important part of the story is (the character, the environment, the other characters in the scene or where they're swinging from) and take it from there.

1 Simple construction lines show the basic shape made by the figure.

Position your facial feature lines, bearing in mind where the focus will be from the camera viewpoint.

2 Add in the joint circles, and think about how the feet are going to look from this angle.

3 Work on the basic figure shape a bit more. This angle is unusual, and will affect the core shapes of the torso.

Always show what a character is swinging on, if possible, to maximize the realism.

Foreshortening this leading foot means that the lower leg is obscured. Check your references to ensure you have this right.

You can see how the original lines have provided the blueprint for the basic form, which is why it's so important to get it right before you move on to the next stage, otherwise it will carry through the whole piece. Erase these lines when you're happy with the character's outline.

4 Start to turn your drawing into a three-dimensional figure, adding form with your cylinders.

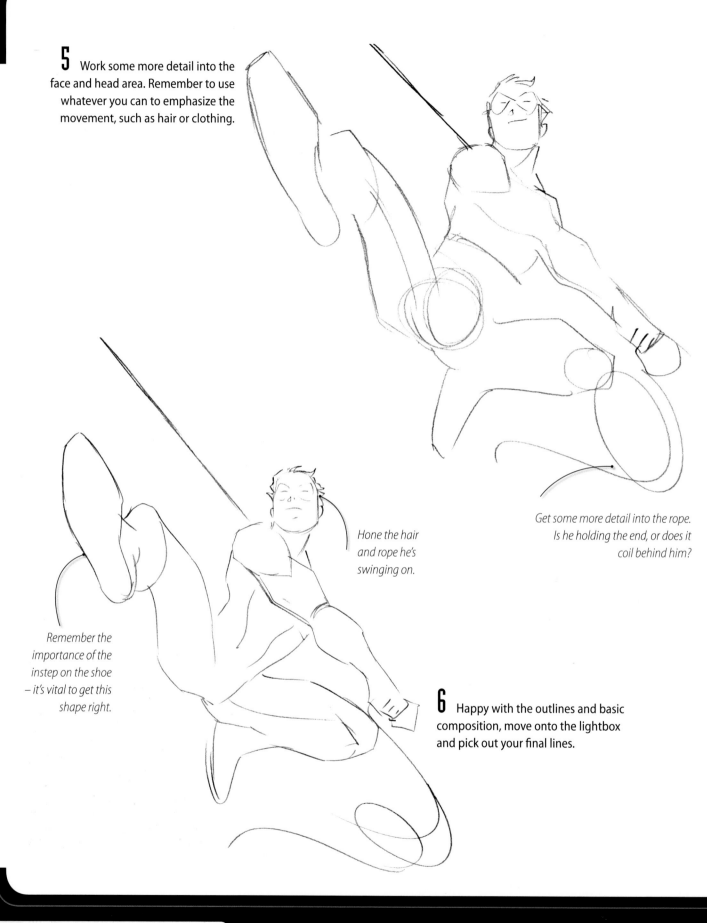

5 Work some more detail into the face and head area. Remember to use whatever you can to emphasize the movement, such as hair or clothing.

Get some more detail into the rope. Is he holding the end, or does it coil behind him?

Hone the hair and rope he's swinging on.

Remember the importance of the instep on the shoe – it's vital to get this shape right.

6 Happy with the outlines and basic composition, move onto the lightbox and pick out your final lines.

7 Introduce some lighting by roughly shading the areas that are not in the direct source. The light here is coming from top left to bottom right, but you can change it if you want to. Having the lighting coming from the camera viewpoint is often effective if the figure is the main focus of the scene.

Work on the rope he's holding. There will be different stresses on the arm that's holding the rope and his bodyweight over the arm that's holding the excess rope. Think about how best to show this, especially as the load-bearing arm is obscured from view.

The shaded and obscured areas of the figure need very little detail. Having the focus on the foreshortened leading leg and just a suggestion of the rest of the figure is all that's needed.

8 Refine your shading and add in the costume hints. Get those all-important details onto the shoe. Showing him above the reader with a clear right–left movement draws you into the image, while the leading, foreshortened leg leads you into the action, where you see the rope he's swinging in on, last.

Basic Action: Flying

The archetypal action for a superhero, flying shots can be effective from a number of angles. Placing the camera beneath the figure and so showing them in the air, means that you don't have much environmental detail to incorporate. Showing the figure on the same level as the reader, as if flying towards them, enables you to show the background they've flown through and you can use buildings and other objects with the vanishing point to help show the movement. Placing the figure so that they're soaring past you is also good to show dynamic action.

1 Flying figures should be graceful and streamlined. The arms are key to demonstrating the action, so think carefully about the basic shape.

2 Showing the head pointing upwards in the direction of travel is a handy way of demonstrating movement. Think about what aspects of the face will be visible, and where.

The legs in this pose are also going to be obscured. This doesn't just mean that you don't have to show them – you have to accurately place them anatomically, and suggest what they're doing behind the figure.

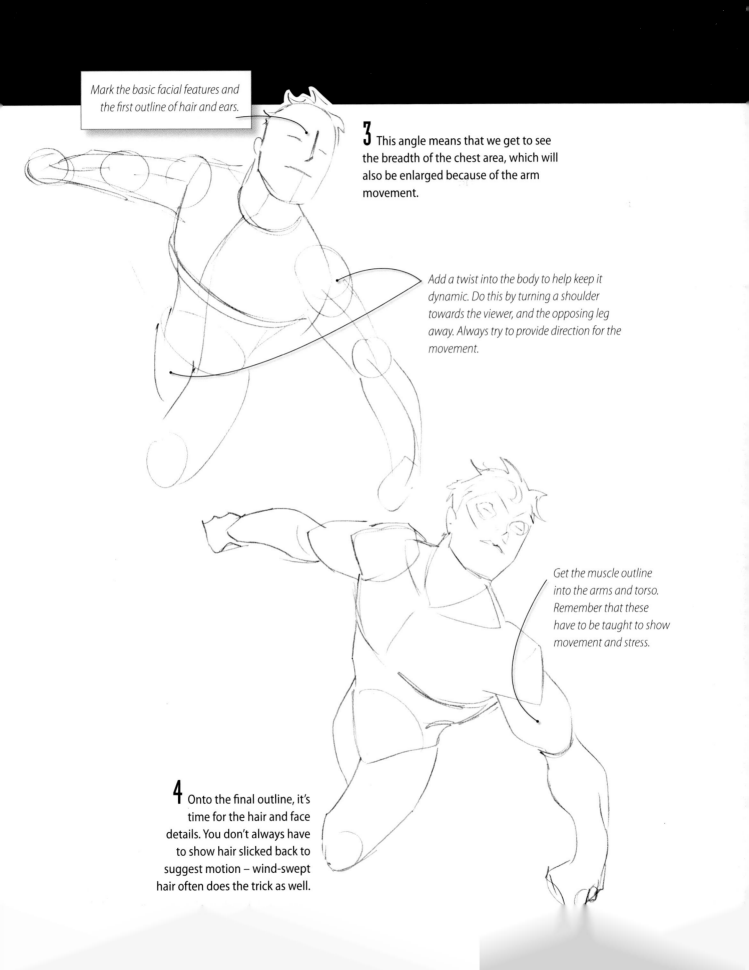

Mark the basic facial features and the first outline of hair and ears.

3 This angle means that we get to see the breadth of the chest area, which will also be enlarged because of the arm movement.

Add a twist into the body to help keep it dynamic. Do this by turning a shoulder towards the viewer, and the opposing leg away. Always try to provide direction for the movement.

Get the muscle outline into the arms and torso. Remember that these have to be taught to show movement and stress.

4 Onto the final outline, it's time for the hair and face details. You don't always have to show hair slicked back to suggest motion – wind-swept hair often does the trick as well.

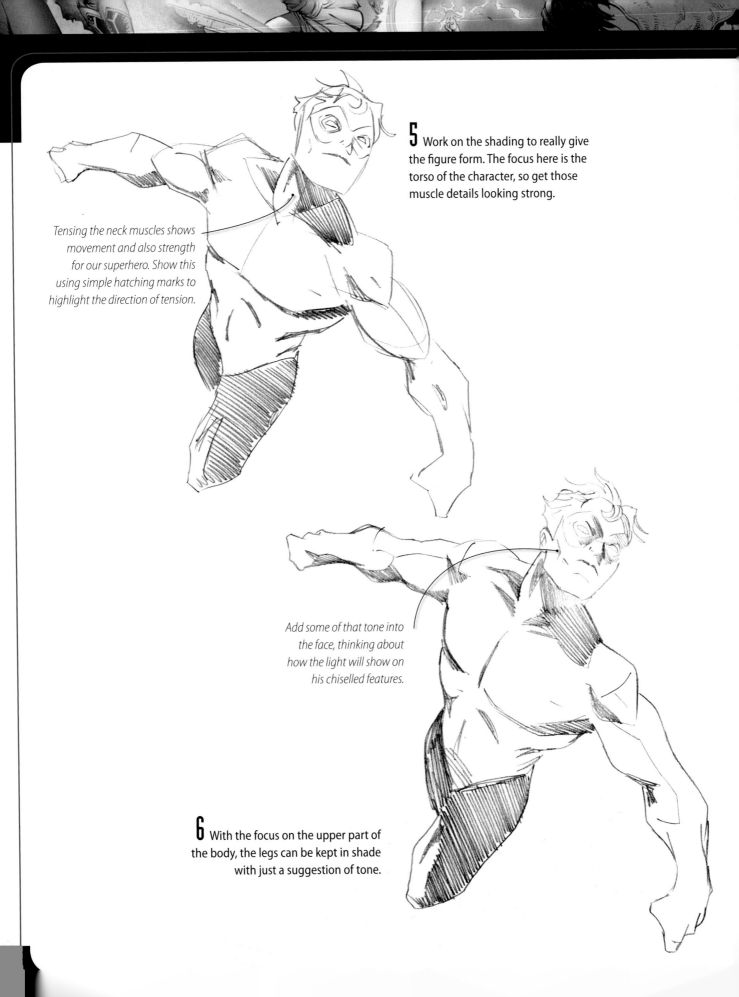

5 Work on the shading to really give the figure form. The focus here is the torso of the character, so get those muscle details looking strong.

Tensing the neck muscles shows movement and also strength for our superhero. Show this using simple hatching marks to highlight the direction of tension.

Add some of that tone into the face, thinking about how the light will show on his chiselled features.

6 With the focus on the upper part of the body, the legs can be kept in shade with just a suggestion of tone.

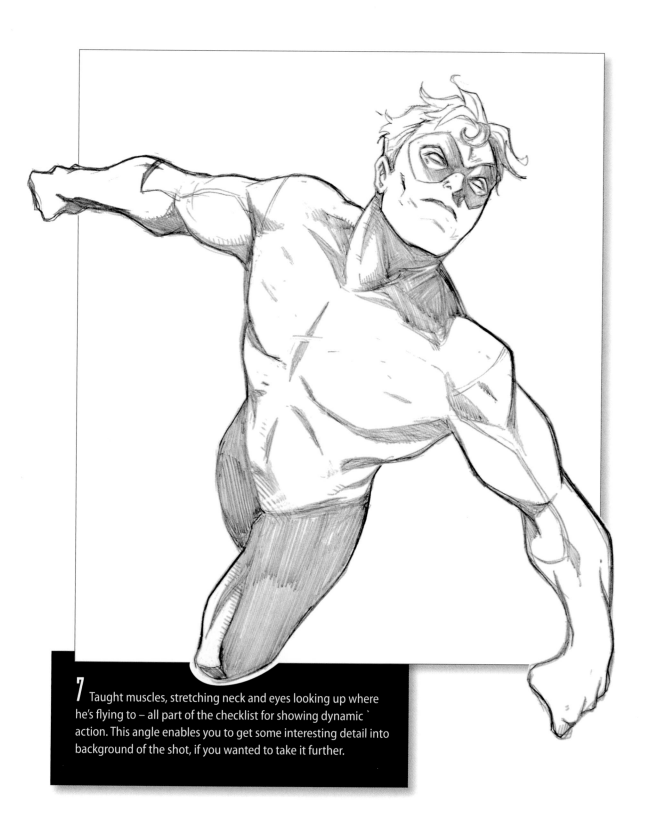

7 Taught muscles, stretching neck and eyes looking up where he's flying to – all part of the checklist for showing dynamic action. This angle enables you to get some interesting detail into background of the shot, if you wanted to take it further.

Basic Action: Leaping

The comic medium enables you to really push your drawing and your characters to the extreme – it's almost expected. When you come to draw your figure in a certain pose, don't just choose the most ordinary, everyday one that comes to mind. Figures – both superhero and everyday humans – can leap in a variety of ways, so choose a pose that illustrates the heroic potential and strength of the character.

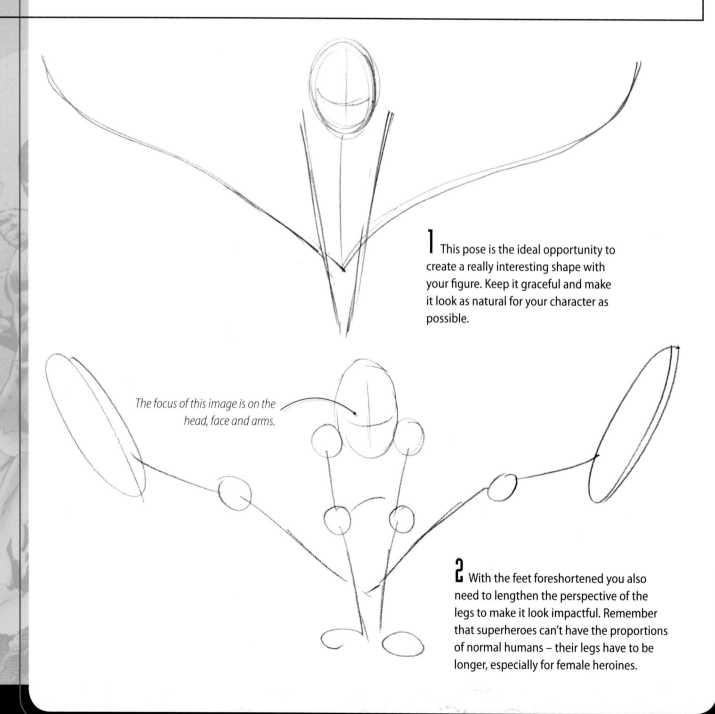

1 This pose is the ideal opportunity to create a really interesting shape with your figure. Keep it graceful and make it look as natural for your character as possible.

The focus of this image is on the head, face and arms.

2 With the feet foreshortened you also need to lengthen the perspective of the legs to make it look impactful. Remember that superheroes can't have the proportions of normal humans – their legs have to be longer, especially for female heroines.

3 The entire force of the character is being carried in the arms and shoulders, so you need to show this. Think about where the arms would need to be placed to bear the weight, as well as how they would look under it.

The hands need to be placed close together to provide stability for the move. Showing them in any other place would be unrealistic and your reader won't believe what you're telling them.

4 Continue working on your basic lines until you're happy with how they're looking. Remember to erase any lines you don't want as you go.

5 Time to work on that final outline. Get a little more detail into the hair and check that you're happy with how it's looking. It should still be quite loose at this stage.

Add in some rough facial details.

Start thinking about the fingers, and how they're going to need to be positioned to support her weight.

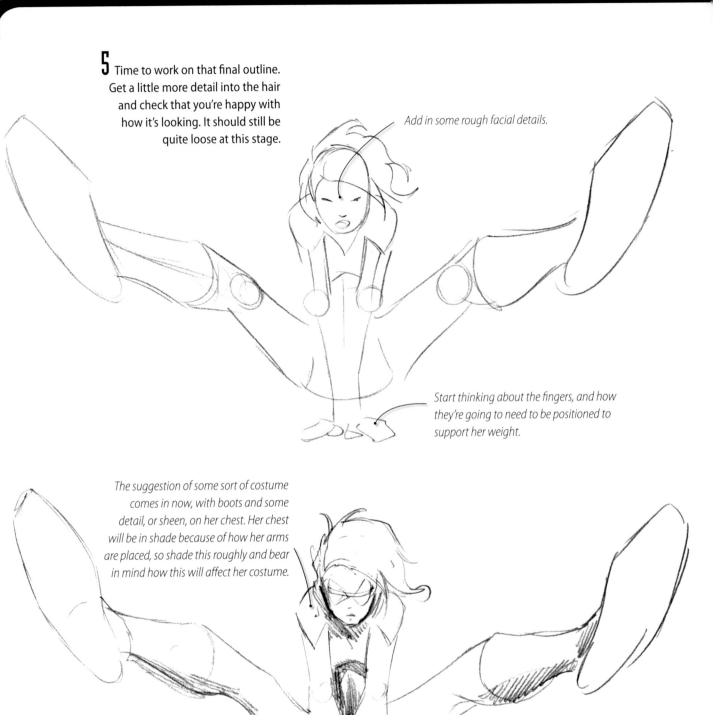

The suggestion of some sort of costume comes in now, with boots and some detail, or sheen, on her chest. Her chest will be in shade because of how her arms are placed, so shade this roughly and bear in mind how this will affect her costume.

6 Take your drawing on to the lightbox (if applicable – see p.102) and work up your final lines. Start adding some detail into her face, and think about the shading under her chin.

Those fingers are starting to take shape now. Think about the position your hands would need to be in to support your weight – they wouldn't be like a fist, and they wouldn't be completely flat either. Check it out in your mirror if you need to.

7 Do some work on her eyes – because of the angle of her head and the way she's looking out from under her eyebrows you can really push the emotion. Get them nice and dark and moody, with a pouting mouth to match.

We don't need much detail in the sole of her shoe – it's more important that it's at the right scale and shaped correctly.

Get some movement and flow into her hair with some simple lines.

Block the fingers in using cylinders at first, and then tighten them up. Think about how her thumbs will be lying.

8 You can see how much more finely you render a female figure than a male one. If one of our male superheroes was in this pose you would have bulging arms and torso, but with a female that isn't necessary. Use graceful lines and make the body look sleek and svelte, without being too muscular. You still convey the action of the pose by using the same devices of foreshortening, weight, direction and focus, but the rendering of the figure itself is different.

Where would your superhero be without being able to swing a devastating high kick onto their nemesis? Consider the camera angle of your shot so that you show it from the most impactful side: having your character face-on enables you to show the facial expression which will convey so much of your story; a side profile means that you will naturally focus more on the environment, body and clothing, while it would be very difficult to achieve the desired impact by shooting from behind. Perspective is key in this type of pose where some parts of the body are going to be closer to the viewer than others, so do lots of research beforehand, arm yourself with plenty of references to help you achieve realistic proportion and do plenty of thumbnails and roughs until you're happy with the way it's looking.

Add in your guides for the facial features. Think about the angle the head is at in order to create the most dynamic expression; here it is angled down menacingly, revealing all of her head but hiding much of her chin and one half of her face.

1 Start your image with a simple stick figure. Try to be loose and fluid and in your pencil strokes to achieve more natural lines.

2 Build up your lines with cylindrical shapes to add form. Keep it simple and clean at this stage, and remember to erase any lines you don't want to keep.

The hands are a vital part of the storytelling process and can carry a lot of information about what's happening in the scene. Try to think about them early in your composition so that you can show them realistically. Having this hand as a clenched fist adds to the aggression of the shot and helps to set the scene.

This is going to be the part of the body that is closest to the camera, so needs to be the largest. Foreshortening (see p. 30) can be hard to master, but it will really help with the storytelling and impact of your work.

3 Tidy up your lines and remove any from the final outline that you don't want. If you are happy with how it's looking, you can also start to remove the joint markings.

4 Pick out your final outline and erase any other unwanted lines.

Get some detail into
the foreshortened boot,
and remember that all
important instep.

The face is going to be important
for conveying the aggression. Think
about the kind of face you would be
pulling if you were doing this move.

This hand doesn't need to be
particularly detailed. You just
need to make it clear that it's
a fist by using the outlines
and a hint of shade.

5 If you're happy with how you're
drawing's looking, take it onto the
lightbox (if applicable – see p.102) and
pick out those final lines. Get some
detail and texture into her hair. Start
thinking about the costume details and
mark these on. Think about the parts of
her body that are visible to the viewer
– with this camera angle there is not
going to be a lot of detail in the parts
we can see, so try to include interesting
(but simple) features where you can,
such as this shoulder.

6 This standing leg is key to getting
the pose right. It shouldn't be straight,
but slightly bent under the pressure,
and your shading should show the
tone in the load-bearing muscles.

7 Start honing that shading and costume detail.

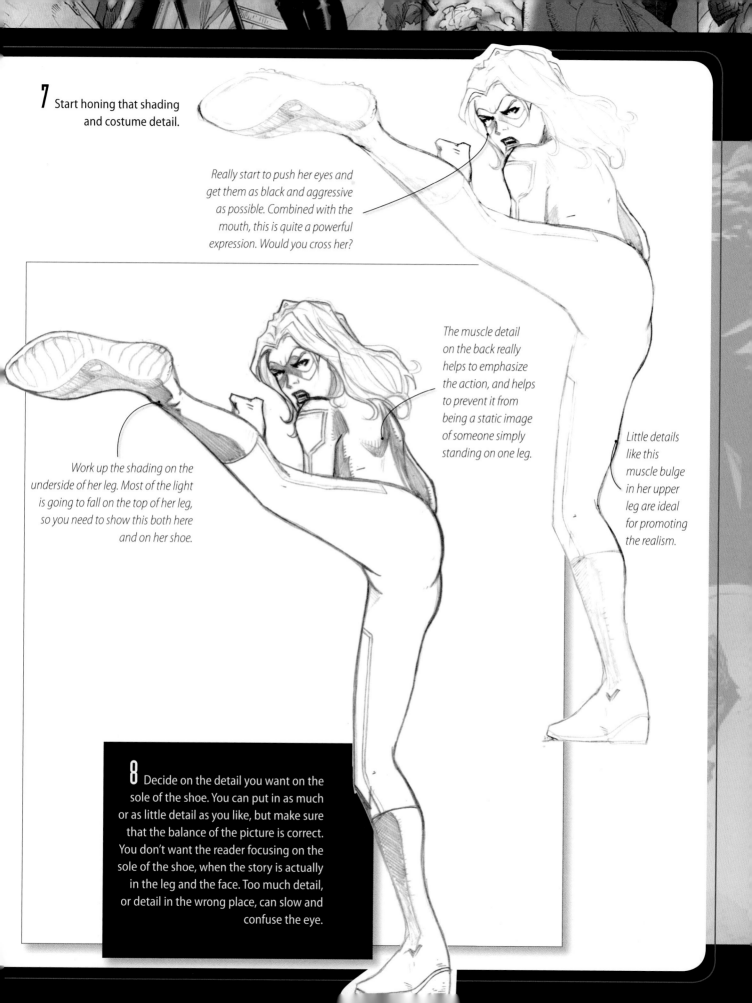

Really start to push her eyes and get them as black and aggressive as possible. Combined with the mouth, this is quite a powerful expression. Would you cross her?

The muscle detail on the back really helps to emphasize the action, and helps to prevent it from being a static image of someone simply standing on one leg.

Little details like this muscle bulge in her upper leg are ideal for promoting the realism.

Work up the shading on the underside of her leg. Most of the light is going to fall on the top of her leg, so you need to show this both here and on her shoe.

8 Decide on the detail you want on the sole of the shoe. You can put in as much or as little detail as you like, but make sure that the balance of the picture is correct. You don't want the reader focusing on the sole of the shoe, when the story is actually in the leg and the face. Too much detail, or detail in the wrong place, can slow and confuse the eye.

Basic Action: Punching

As with any action pose, punching can be portrayed in a number of ways, from lots of different angles. Whatever your angle, the most important thing is that you show the moment just before or just after the impact, rather than the punch itself. Showing the punch itself will look static, and your options for conveying the reaction of the person being punched are limited. Show the follow-through of the impact to get maximum power, movement and dynamism.

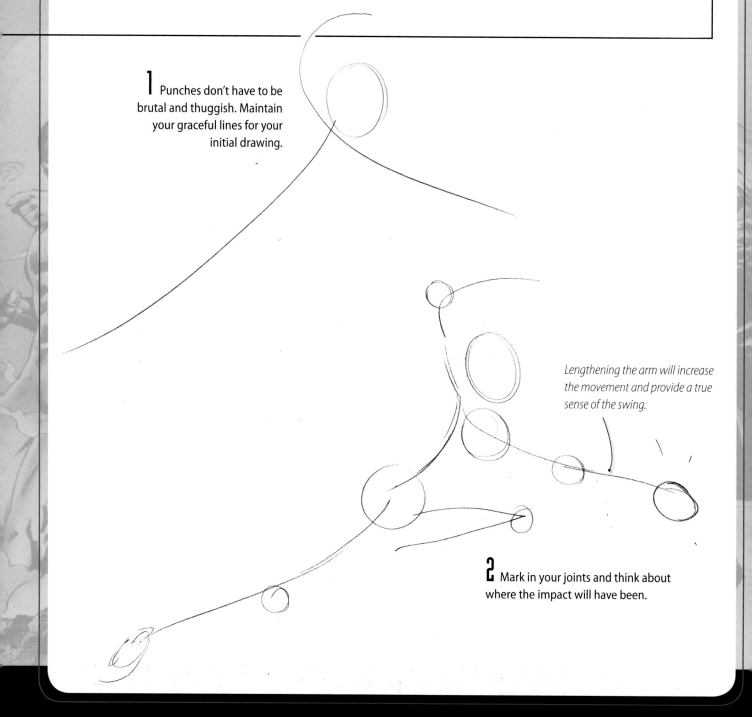

1 Punches don't have to be brutal and thuggish. Maintain your graceful lines for your initial drawing.

Lengthening the arm will increase the movement and provide a true sense of the swing.

2 Mark in your joints and think about where the impact will have been.

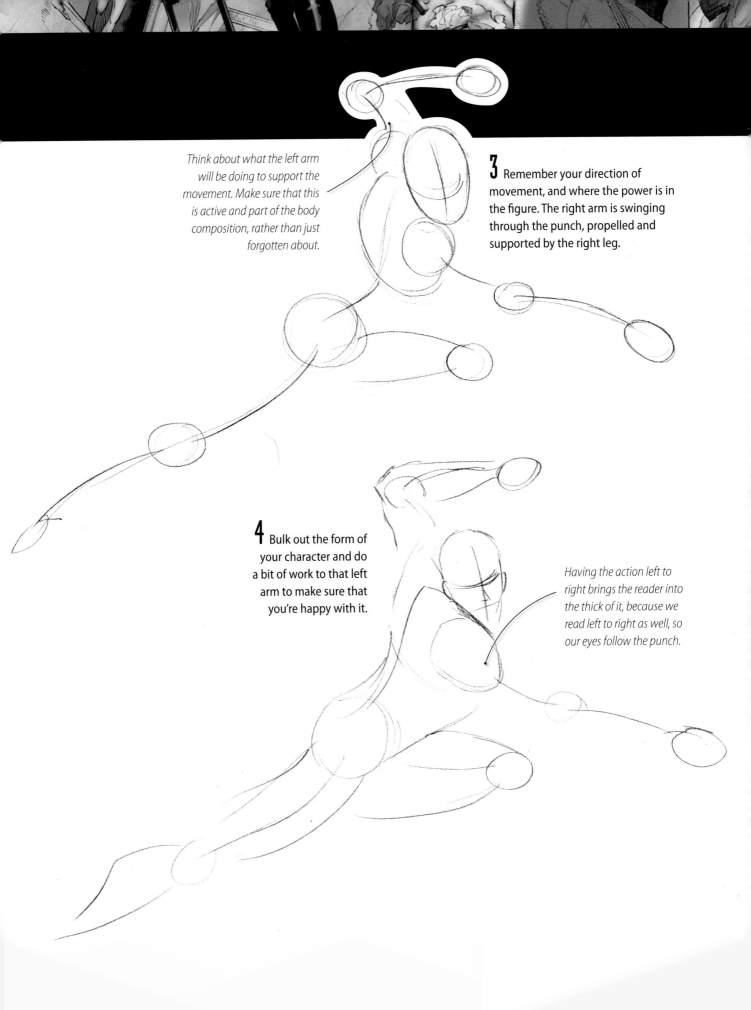

Think about what the left arm will be doing to support the movement. Make sure that this is active and part of the body composition, rather than just forgotten about.

3 Remember your direction of movement, and where the power is in the figure. The right arm is swinging through the punch, propelled and supported by the right leg.

4 Bulk out the form of your character and do a bit of work to that left arm to make sure that you're happy with it.

Having the action left to right brings the reader into the thick of it, because we read left to right as well, so our eyes follow the punch.

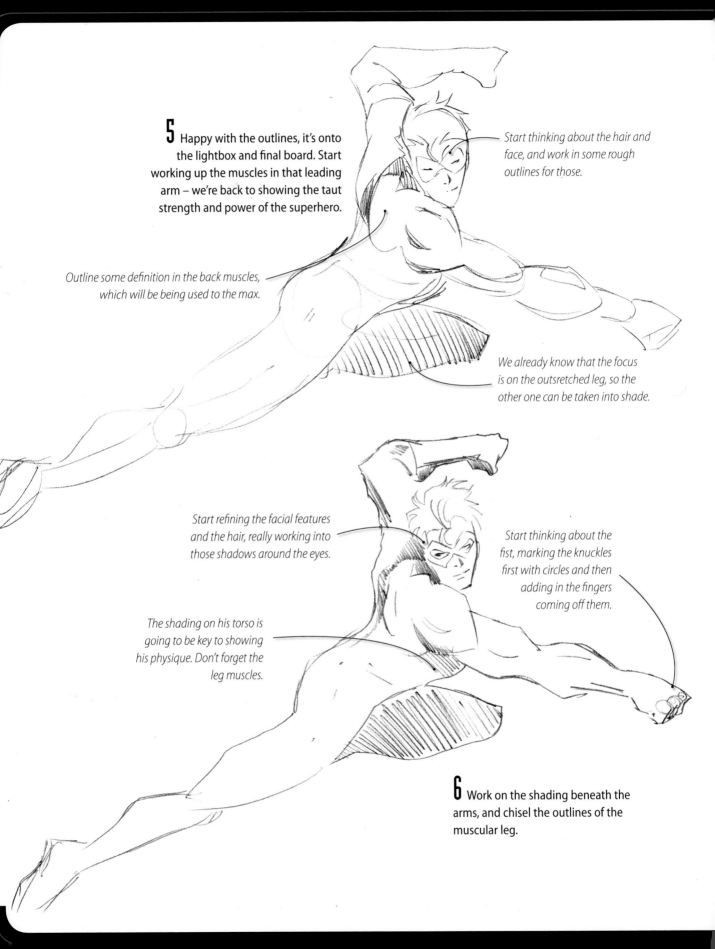

5 Happy with the outlines, it's onto the lightbox and final board. Start working up the muscles in that leading arm – we're back to showing the taut strength and power of the superhero.

Start thinking about the hair and face, and work in some rough outlines for those.

Outline some definition in the back muscles, which will be being used to the max.

We already know that the focus is on the outsretched leg, so the other one can be taken into shade.

Start refining the facial features and the hair, really working into those shadows around the eyes.

Start thinking about the fist, marking the knuckles first with circles and then adding in the fingers coming off them.

The shading on his torso is going to be key to showing his physique. Don't forget the leg muscles.

6 Work on the shading beneath the arms, and chisel the outlines of the muscular leg.

7 You can see that not having either feet in the image doesn't affect the impact or your understanding of it. Sometime's the eye needs very little information to understand what's happening or where something is.

8 Refine and soften the shading so that it blends more naturally from the dark to the light. The twist in his body really adds to the power of the punch and the impact it has on the reader – it also adds to the sense of movement. Having a character standing on two feet just showing the punch would look static and dull.

Fight Action

Fight scenes are great fun to draw – it's where you as the artist really get to cut loose. Fighting is the essence of comics; they all boil down to good versus evil in giant, fantastical battles.

Tips for success

There are two key elements that you need to master in order to create a powerful, believable fight scene. Firstly, you have to get a sense of power and energy into them, otherwise they will just be flat. Every blow has to feel like it's really powerful – like it's been ploughed into the opposition's body and it's really hurt. Creating fight scenes means that now more than ever you have to really push the action to extremes.

The second element is clarity. You have to make sure that the reader can look at a panel and know instantly who's in it, what they're doing and where they're doing it. This might sound simple, but you'd be amazed how tricky it can get if you're creating a big fight scene with lots of different characters dotted around the composition.

Power

Your villains need to look really powerful, otherwise there's no sense of danger in the image. And if the villain is a superhero, they need to be doing what ordinary people can't in order for the power to come across. It helps to always have someone winning in the fight scene to keep the action dynamic and hold the reader's interest – who that is can change according to who you want to be the ultimate victor.

Planning

Your script of course dictates the kind of fight action that's needed, but often you will get little more than an instruction to devote the next six pages to a fight scene. This is where it's important to plan out your fight, and work out your pacing carefully. The fight scene not only needs to have some sort of escalation, you also need to keep the reader engaged and the panels fresh. This can be tricky, so use all of the devices in your toolbox – vary your camera angles, types of fighting, and have some wider shots that show the environment the fight is taking place in and what it looks like from a different angle.

Johnny Alpha, a mutant bounty hunter, from *Strontium Dog*.

Showing a battle from above, such as a from a helicopter, is a good trick as it shows the action and devastation in context. Although the focus in a fight scene is on the characters and the action, it's important to occasionally show the context of the fight, not just from a pacing point of view but to enhance the storytelling.

You can use photo reference for your fight scenes, but try to push yourself out of that zone and really use your imagination. A lot of photo reference can be dead and static, so let your mind run wild and play to the power of the shot and the characters.

Kaboom!

We're all familiar with the sound effects that the letterer often puts on comics, and this can look really strong and graphic and become part of the design of the page. You can't allow your fight scene to rest on this lettering though – the storytelling should be strong enough without the added onomatopoeia. If you know that these sound effects are going to be added in you will of course need to compose your panels so that there are 'dead' areas with little information into which they can be put, much as you would for speech bubbles.

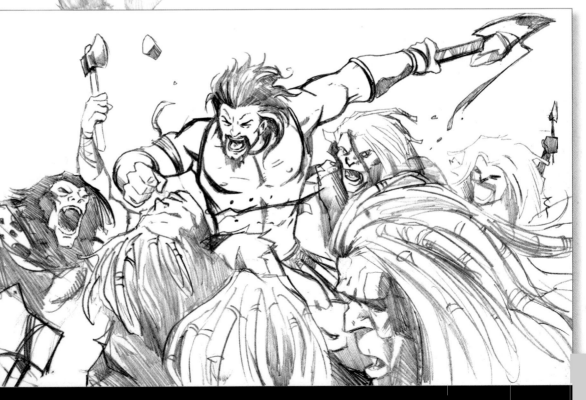

Pitching your character in the thick of an intense battle creates a sense of danger and tension. Placing elements in the foreground and distance gives the impression of wave after wave of enemies and pushes that tension even more.

Fight scenes are where it's vital to show the right stage of the action. You don't want to show the exact moment of impact, as this would look too static and lack impact. Instead, you need to show the split seconds just before or just after – the downswing of the fist that's taken out the enemy, or the crunching of the villain's face as the boot sinks into it.

Showing the victim's eyes closed is a powerful way to demonstrate the impact. His head is thrown back as a result of the force of the blow, and his eyes are shut in shock and pain.

Her expression shows the emotion clearly – the aggression is written into every element of her face.

This is the moment just after the punch has landed. The assailant is still on the downswing from the punch, and showing this really enforces the movement and power in the image.

Having her other hand clenched into a fist is also effective as a demonstration of power. Think about how the inactive arms and hands would react to the force of the swing – they would help with balance and also display the emotion, rather than lie relaxed at the side.

These close-up shots are important for expressing the detail, but you can't have a whole page of them. Plan your sequence carefully so that the power of the fight lands in these close-up panels, with the next panel showing the camera pulled out for a change of pace.

Kicking is a good variation to punching fight action.

This is as close to the moment of impact as you want to get. It is that split second after the boot has landed, and the facial expression tells the story.

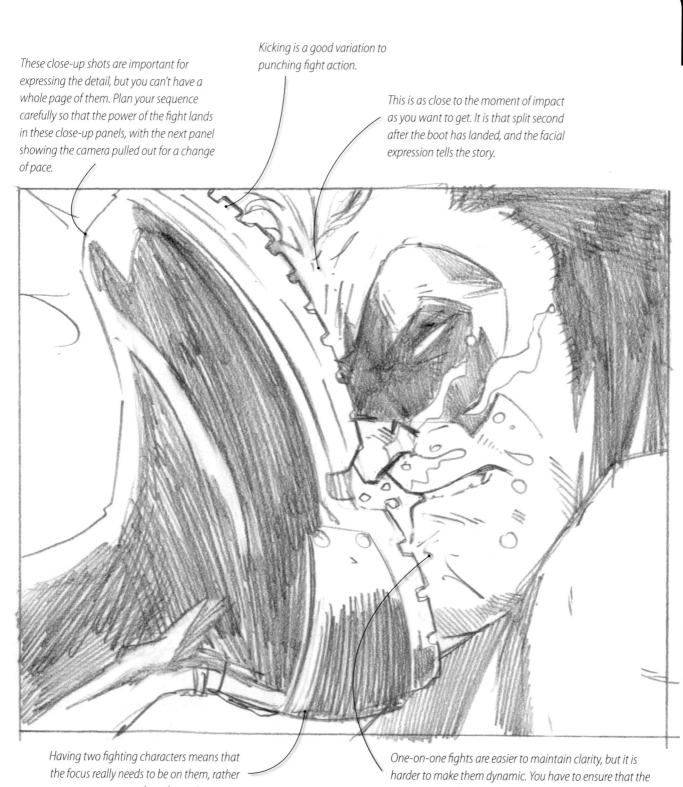

Having two fighting characters means that the focus really needs to be on them, rather than the environment.

One-on-one fights are easier to maintain clarity, but it is harder to make them dynamic. You have to ensure that the movement and power is immediately apparent, and that every part of the figure tells the story.

Weapons

A fight scene involving guns can be shown effectively in a number of ways. You can have the bullet flying in slow-motion towards the victim, or show the recoil of the victim as it hits them. You don't need to show both the shooter and the victim for a gun fight to be effective.

This camera angle puts the reader in the thick of the action, creating tension and impact.

A smoking gun tells the same story as one that is going off. The emotion, as ever, is in the face of the character, especially if the focus of the scene is just on one figure.

Having a calm, composed character at the peak of the action can be as powerful as an irate one.

This is the moment the bullet shoots out of the barrel. You know exactly what's going on in the panel and exactly what the sound effect is, without having it written in.

You can see from this empty space how the lettering might be placed in this shot.

This camera angle focuses the reader on the explosion coming out of the gun – more of the picture is given over to the shot than the actual figure, yet the figure, rather than the environment, is still the central part.

The taut arm of the shooter demonstrates the force with which he's holding the weapon and bracing against the kick-back of the gun.

This camera angle enables us to see everything that's happened in the panel, with a background context and the victim on the deck. The shooter is the central, dominant figure and where your eye looks first, before moving on to the devastation around him.

This is an aftermath shot, with the shooter standing victoriously over his victim, the gun still smoking. Even though we can't see the whole face the body language tells the story.

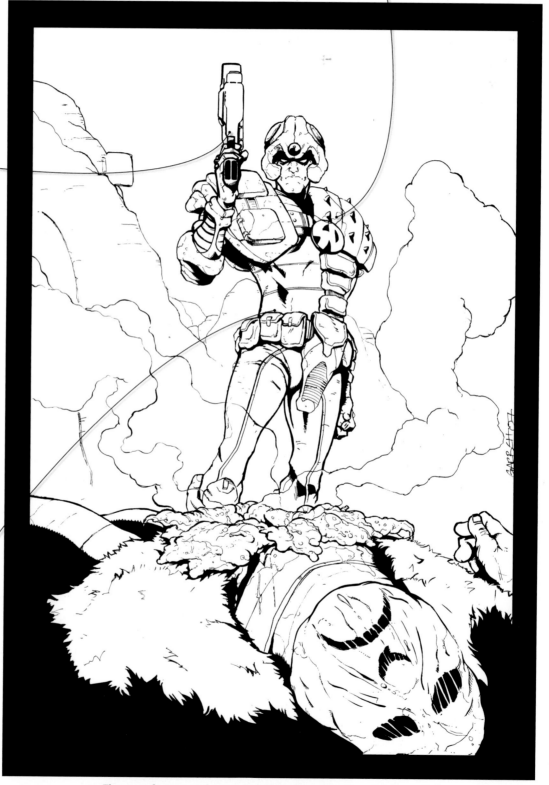

Having the reader looking up at the central figure creates a sense of power.

The most famous and respected of the Strontium Dogs is Johnny Alpha

Explosions

Explosions are the archetype of any comic, generally accompanied by a 'kaboom' or 'pow'. While you can show an explosion well enough without characters, putting them in helps to tell the story and also demonstrates the force of the explosion. It is also a good way of showing that the superhero can survive what ordinary people can't.

All of the action in this shot is coming at the reader – the characters, the flames, the debris and the smoke – creating maximum impact.

Don't just scatter debris randomly around – think about what kind of explosion it is and where it's taking place, and plan how the debris would fly out in certain directions. Creating increasing circles of rubble around the centre of the explosion is good way to start.

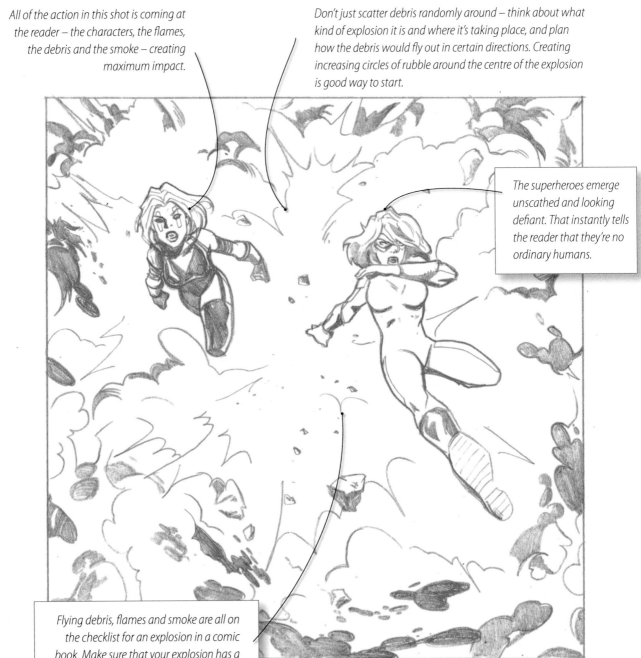

The superheroes emerge unscathed and looking defiant. That instantly tells the reader that they're no ordinary humans.

Flying debris, flames and smoke are all on the checklist for an explosion in a comic book. Make sure that your explosion has a central point that is its most powerful.

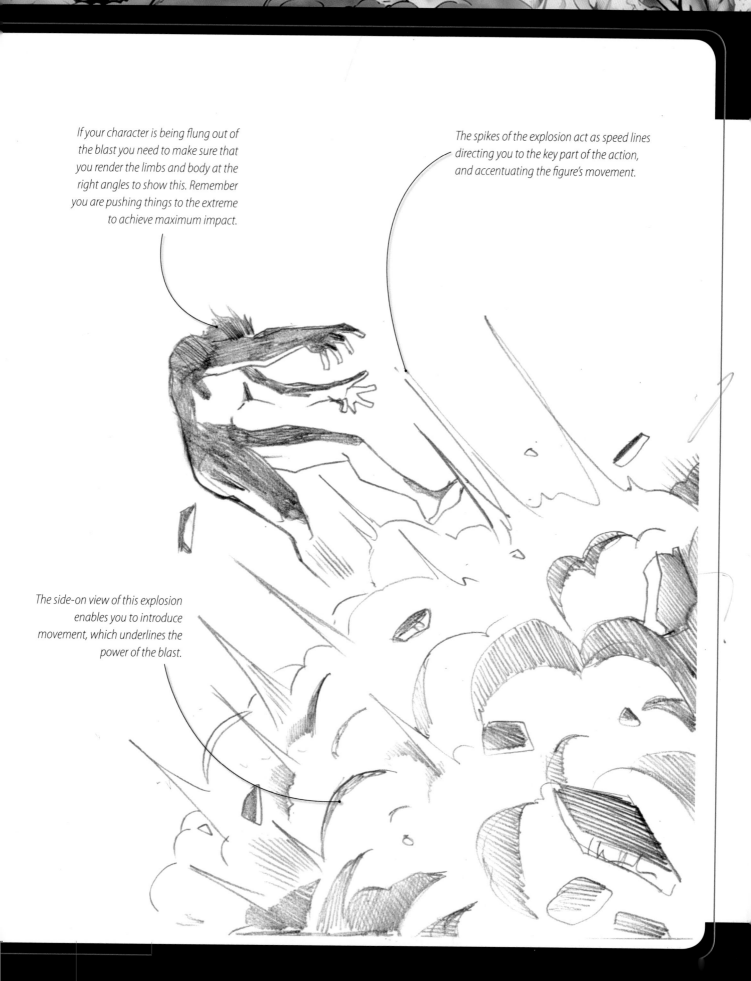

If your character is being flung out of the blast you need to make sure that you render the limbs and body at the right angles to show this. Remember you are pushing things to the extreme to achieve maximum impact.

The spikes of the explosion act as speed lines directing you to the key part of the action, and accentuating the figure's movement.

The side-on view of this explosion enables you to introduce movement, which underlines the power of the blast.

Scenery Interaction

If we're dealing with comics, superheroes and extremes, then at some point you're going to have to show a character using something from the surrounding environment as both a weapon and a demonstration of brute force. Cars, trees, lampposts, skyscrapers – nothing is safe!

Scenery interaction can literally be anything you want it to be. Here, the character is being punched through a wall.

This type of shot gives you some fun options for the panels leading up to this. You could have a huge fist flying at the face of the reader, or show the character just before the impact.

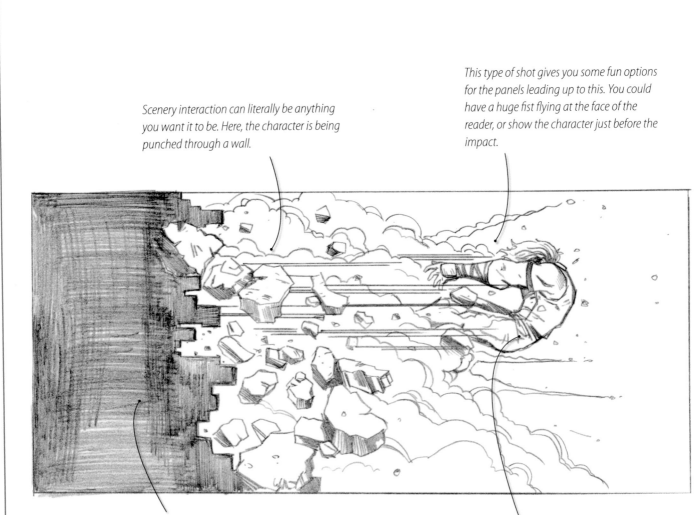

Let your imagination run wild with fight scenes like this. The more fantastic and awesome it is the better.

The body shape again expresses the force, movement and direction of the figure.

Rough out your panel composition until you're happy it works.

Scale can be a tricky thing to get right in these shots. It can be effective to have a really tiny person holding up a car, but you will struggle to get the necessary detail in the arms and legs to make it really plausible.

Make sure that your detail elements are realistic, so the legs and arms look as if they're bearing the weight of a car.

Whatever the action, just make sure it's true to the character – for example, Batgirl is only 19 and can't fight like the Hulk, so she can't be portrayed in that way. You must stay true to the story to be believable, because people will notice!

Putting the reader behind the other character in the scene provides context and perspective, which are vital components if we're to believe this is real. We have to see what else is going on for it to make sense.

Team Fights

This is where the action gets more difficult. With more than one, two or even three people in the scene the composition becomes more of a challenge. Team and group fight scenes naturally need to be busy and packed with energy. Team fights are generally a bit more complicated to draw than group fights. They not only require the scene to be packed with weapons, debris, limbs, and sound effects, but also multiple goodies (on the same team) and baddies, along with speech bubbles to match. How do you get all of that action in a panel and still make sense?

Speech bubbles can, in theory, go anywhere, but they look neatest and are easiest to follow if they are next to the character they relate to – either alongside or above. Work out your amount of dialogue and leave areas for them where there is little detail.

First of all, work out exactly where the fight is happening, who needs to be in the panel, who needs to be speaking and start roughing that out.

Work out where you want the focus of the panel to be. What do you want the reader to see first, and what do you then want them to go on and see next?

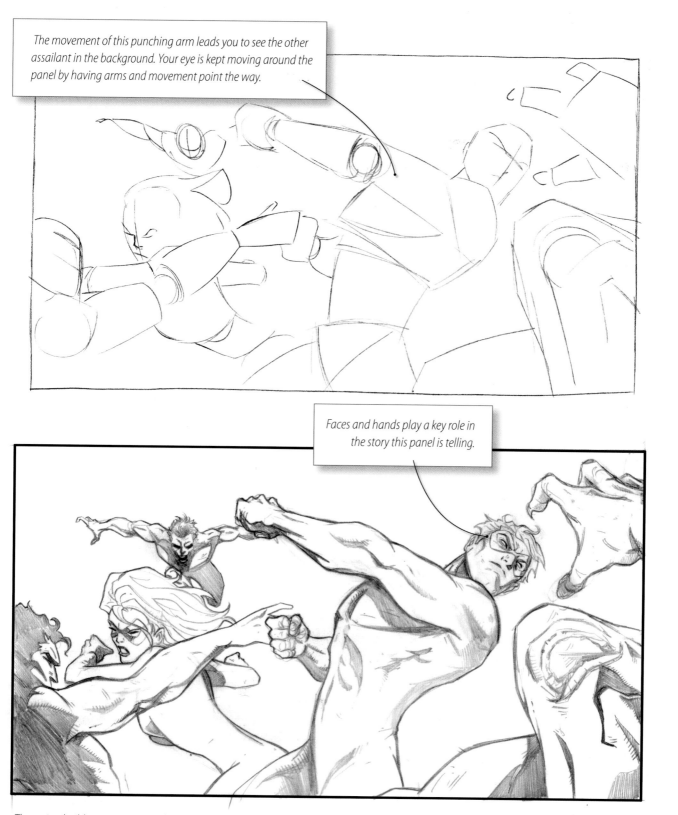

The movement of this punching arm leads you to see the other assailant in the background. Your eye is kept moving around the panel by having arms and movement point the way.

Faces and hands play a key role in the story this panel is telling.

The action builds up as we read left to right. You first of all see the female character post-punch, and the arm of her victim leads you on to the action in the middle and right, ending the panel by seeing the face of the other victim in the bottom right.

Group Fights

Many of the challenges presented by team fights are going to need to be overcome with group fights. The one relief is that you're less likely to need speech bubbles here, as the panel is generally all about the action centred on one 'good' character.
You may well need to allow room for lettering though, so bear that in mind.

Draw as many variations as you need to get it right. You can't afford to waste your time starting the finished pencils only to discover it doesn't work compositionally.

Compositionally, panels with lots of people in can be tricky. You need to make sure that the reader sees what you want them to see, in the right order, and you need to make sure that you can fit everyone in.

Begin by drawing some really quick thumbnails outlining the characters and the action. This is just an exercise to make sure that you've got the placement correct.

The central focal point puts the reader
right in the action – you don't want
them to feel like a spectator.

Happy with the composition you've chosen,
start to work up the final outlines.

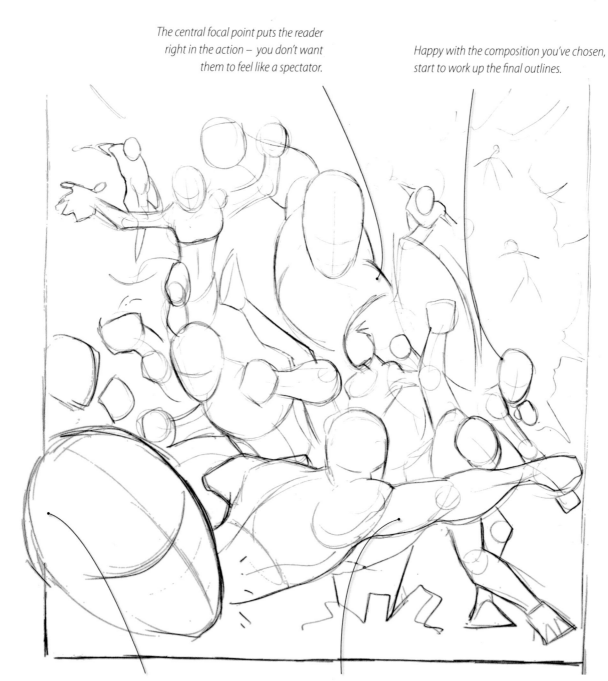

Having body parts breaking out
of the panel creates impact and
really emphasizes the action.

You can still tweak, change and improve things at this
stage if you want – it's not set in stone, and if you see a
better way of doing something or discover how to get
more impact then do it.

You can keep the distant figures as stick outlines for now – they're not going to be rich in detail so you just need to suggest their placement at the moment.

If you're happy with your lines, move onto the lightbox and start your finished piece. Use your cylinders and shapes to add form.

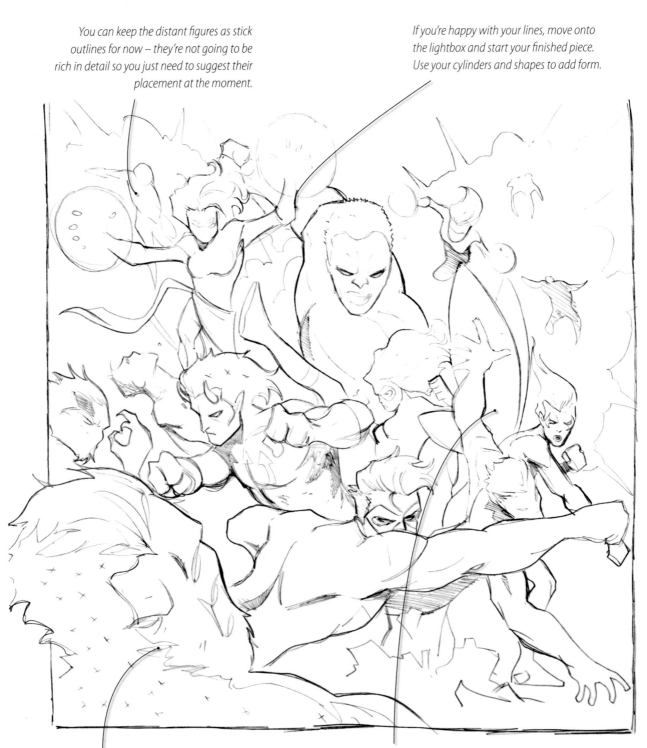

The lines should still be quite loose and formative at this stage, until you're happy with everything and are ready to move on.

Having so many characters in the panel means that you have to get the perspective and scale right – adding an invisible horizon line and making sure everyone is in the correct position in proportion to this is a good tip.

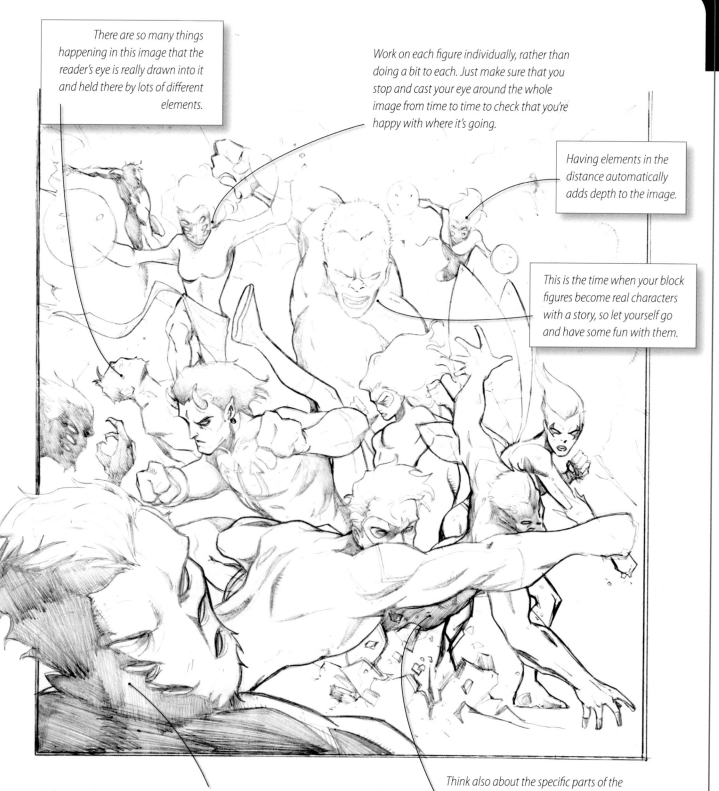

There are so many things happening in this image that the reader's eye is really drawn into it and held there by lots of different elements.

Work on each figure individually, rather than doing a bit to each. Just make sure that you stop and cast your eye around the whole image from time to time to check that you're happy with where it's going.

Having elements in the distance automatically adds depth to the image.

This is the time when your block figures become real characters with a story, so let yourself go and have some fun with them.

Lighting and tone is going to be key in this image, with so many different elements. Think carefully about which figures are going to be in light and shade.

Think also about the specific parts of the figures that we're going to see more or less of, and start blocking that shade in.

Action File

The script that you're working to determines the type of action that is taking part in the story, and it is your job as the artist to represent that in a realistic and captivating way.

In the thick of it

The reader needs to always feel like they are part of the action, rather than just a spectator. Having characters or action coming at the reader is the most impactful way of doing this – avoid side profiles and distant shots where the focus in on the environment rather than the action. You will of course need these environment shots from time to time in order to establish a scene or provide a change of pace, but make sure that the focal point of the action in the story is the focal part of your panel.

Action poses

Superheroes need to be doing superheroic things, and there are several standard poses that you are going to need to be able to draw. Over the next few pages we have included a few to get you started, but use these as a springboard for your imagination and start to develop your own poses, perspectives and camera angles from them.

Practise is the only way to really get these right, so draw as many as you can as often as you can. People-watching is a great way of building up your collection of poses and building up your reference collection. Remember that comic art needs to go to the extremes, so be creative with the kind of reference you use – don't try to draw someone running because this will look static. Instead, draw someone speed skating to really get the energy into your work. And remember the best aids of all – a mirror and a camera phone. You don't have copyright issues when drawing yourself, either!

Figure drawing basics

The basics of figure drawing remain crucial here – you need to depict the weight in the momentum correctly, and you need to watch and see how muscles and the body in general responds to weight bearing and stress. Always give your characters a sense of direction in the movements, and use lighting to add tone and form.

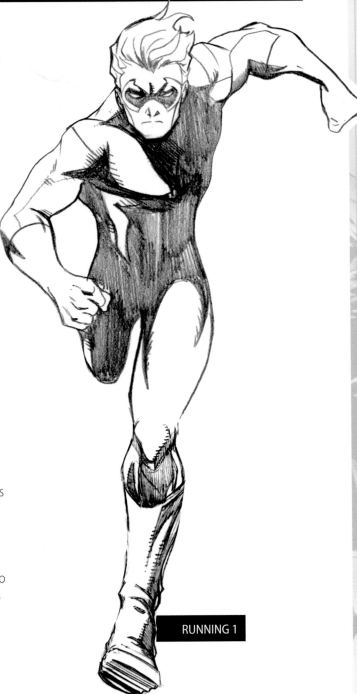

RUNNING 1

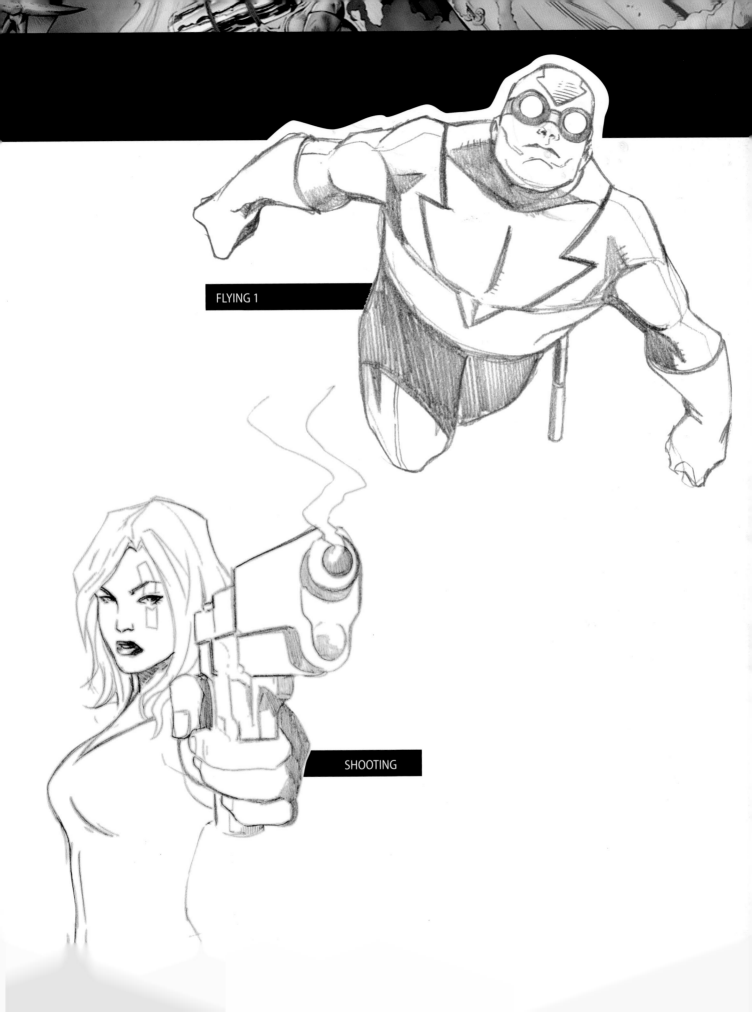

FLYING 1

SHOOTING

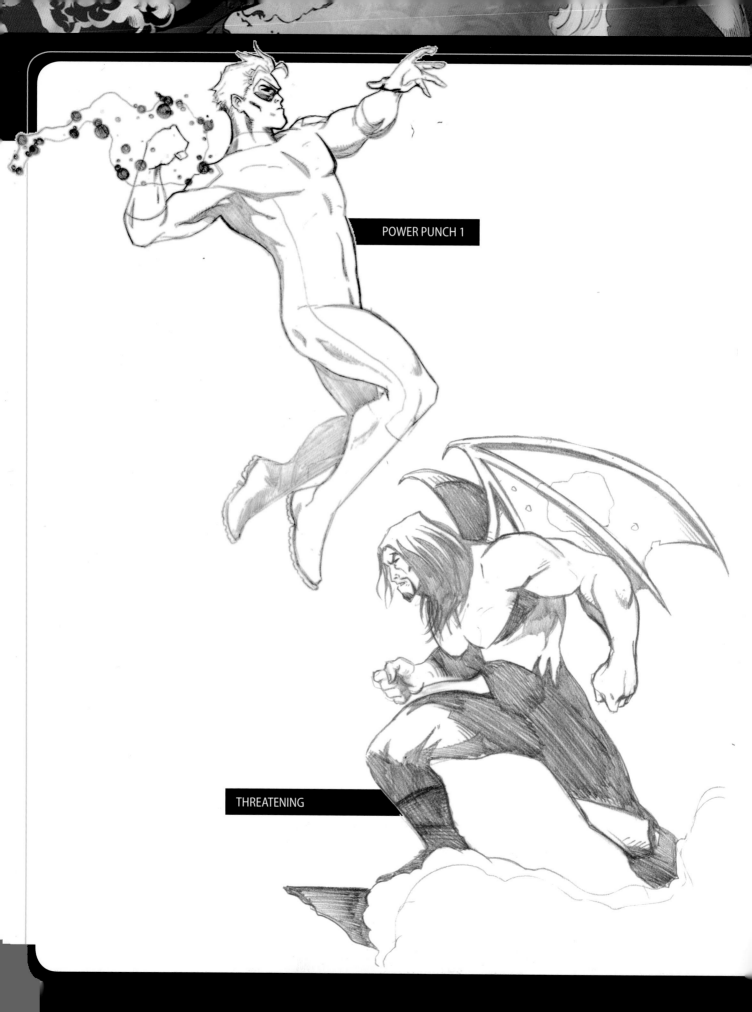

POWER PUNCH 1

THREATENING

POWER SQUAT

FLYING 2

SWINGING KICK

RUNNING 2

SWINGING

LEAPING GRAB

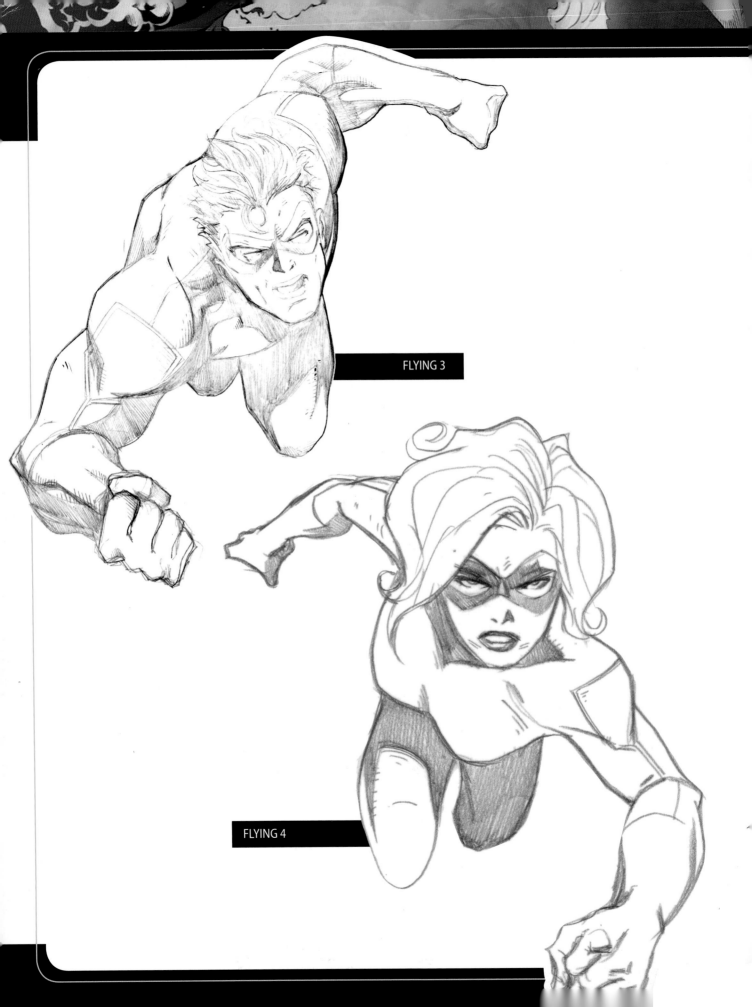

FLYING 3

FLYING 4

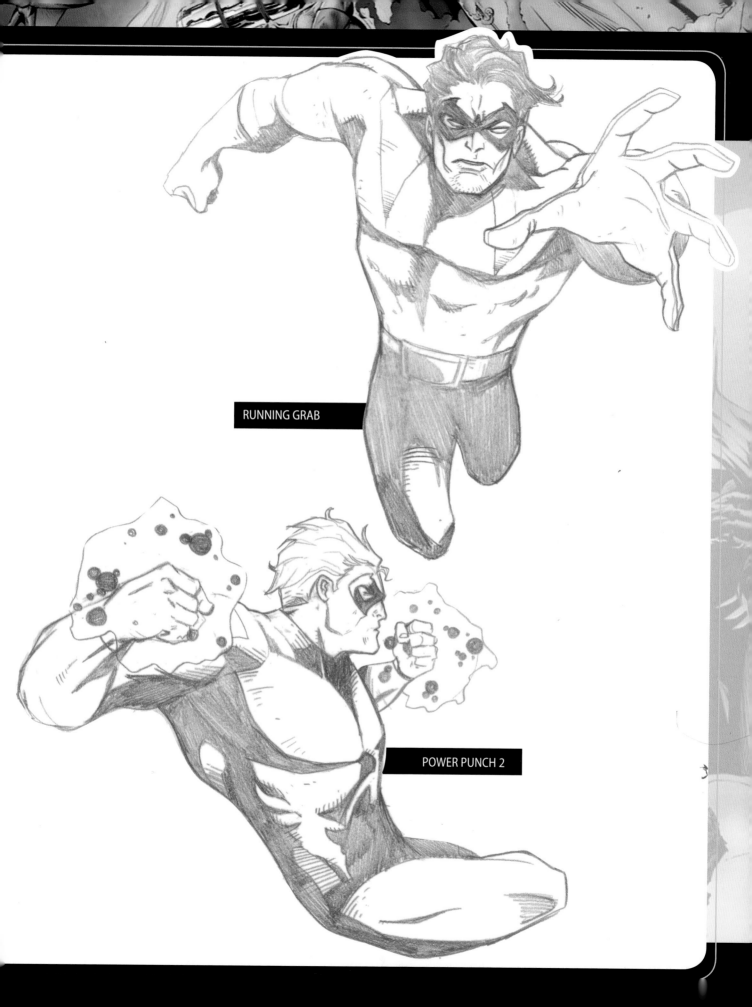

RUNNING GRAB

POWER PUNCH 2

Camera Angles

The angle you show the story in your panel from is a crucial decision. You have to carefully consider what's happening in the story, what you need to show in terms of environment or characters, and also the pacing of the story running up to and beyond each panel.

Roughing out your composition is the best way of starting any comic book, and it is a good idea to quickly sketch a thumbnail to see what your story would look like from different angles. Your job is to tell the story with maximum impact, so you need to find the best possible viewpoint to do that.

There are no hard and fast rules, but there are some standard angles that not only show the story from the best angle, they can actually help to tell the story. Here are some ideas to get you started.

POWER PUNCH 1

All the tricks to convey power and movement are here.

This perspective allows us to see the victim in close range, but more importantly we see the whole of the attacker's body, enabling us to see the full force of the blow.

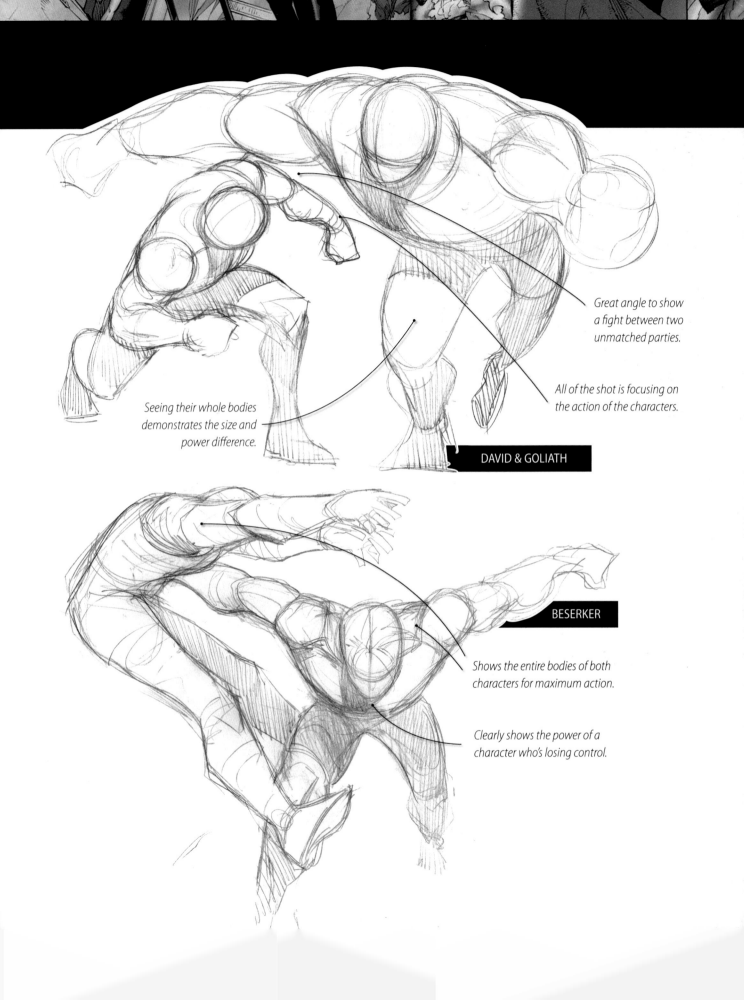

Great angle to show
a fight between two
unmatched parties.

All of the shot is focusing on
the action of the characters.

Seeing their whole bodies
demonstrates the size and
power difference.

DAVID & GOLIATH

BESERKER

Shows the entire bodies of both
characters for maximum action.

Clearly shows the power of a
character who's losing control.

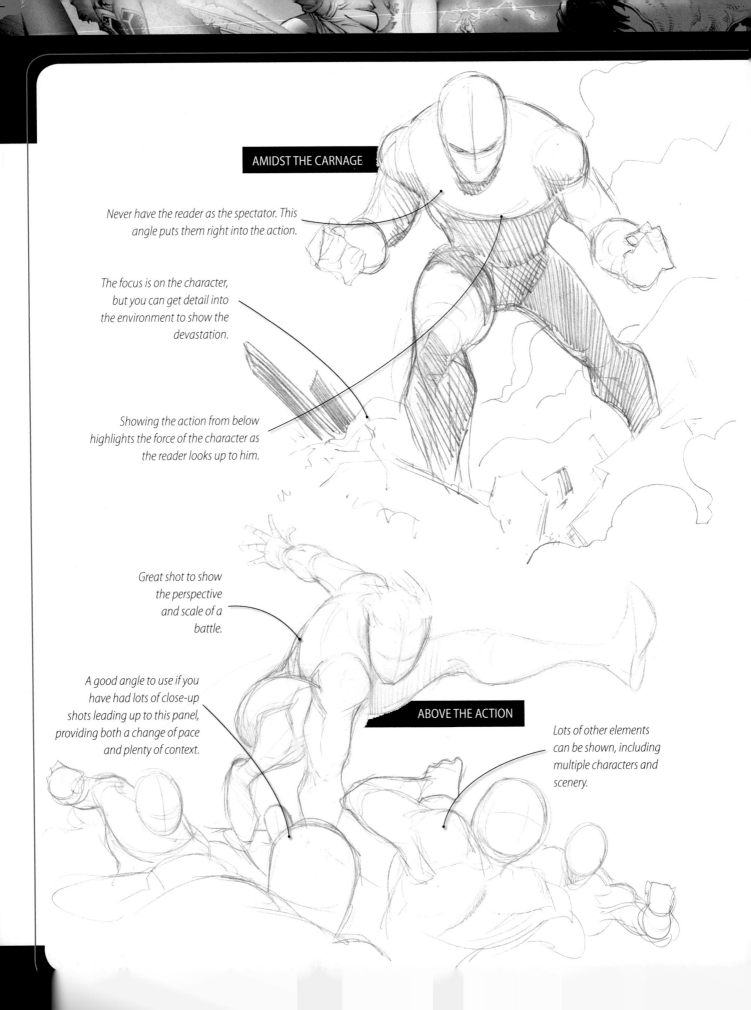

AMIDST THE CARNAGE

Never have the reader as the spectator. This angle puts them right into the action.

The focus is on the character, but you can get detail into the environment to show the devastation.

Showing the action from below highlights the force of the character as the reader looks up to him.

Great shot to show the perspective and scale of a battle.

A good angle to use if you have had lots of close-up shots leading up to this panel, providing both a change of pace and plenty of context.

ABOVE THE ACTION

Lots of other elements can be shown, including multiple characters and scenery.

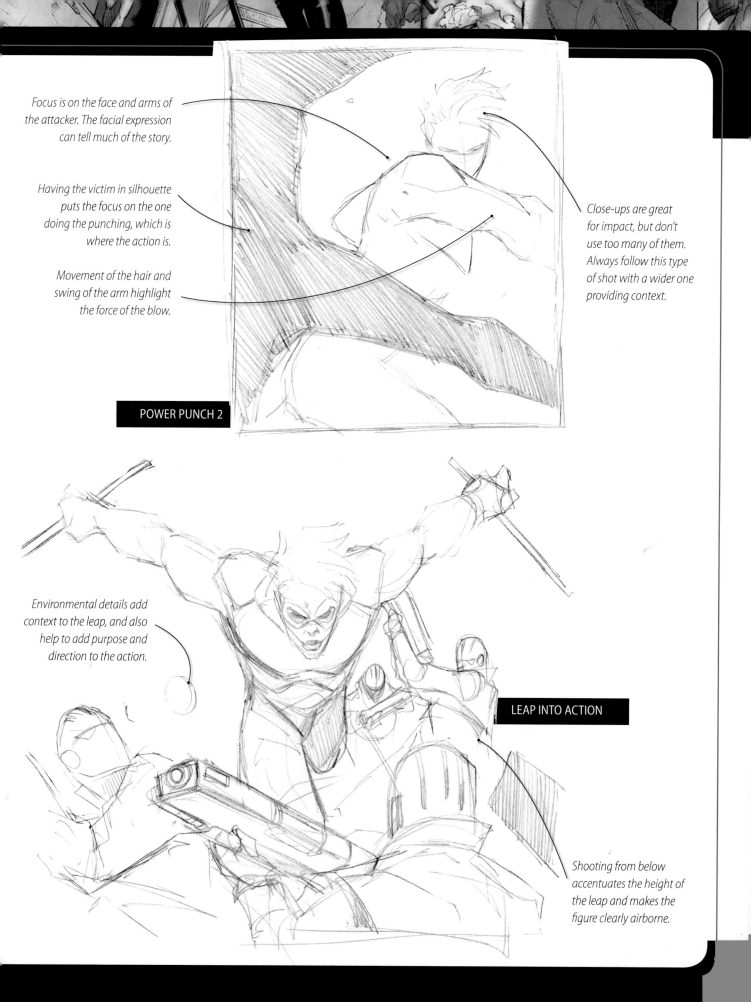

Focus is on the face and arms of the attacker. The facial expression can tell much of the story.

Having the victim in silhouette puts the focus on the one doing the punching, which is where the action is.

Movement of the hair and swing of the arm highlight the force of the blow.

Close-ups are great for impact, but don't use too many of them. Always follow this type of shot with a wider one providing context.

POWER PUNCH 2

Environmental details add context to the leap, and also help to add purpose and direction to the action.

LEAP INTO ACTION

Shooting from below accentuates the height of the leap and makes the figure clearly airborne.

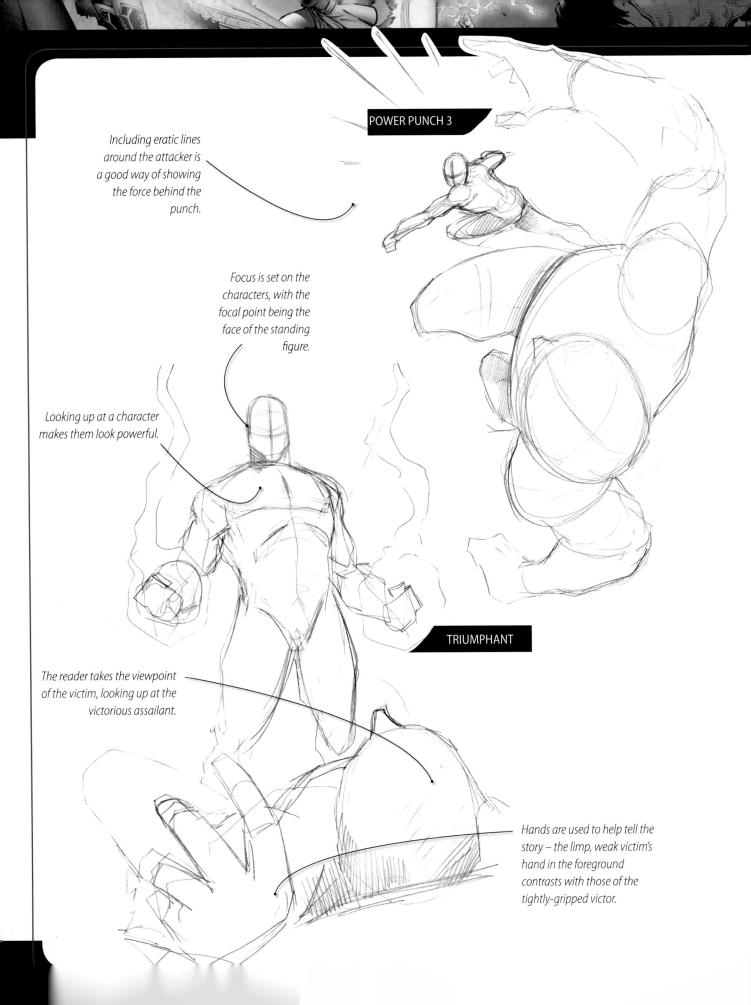

POWER PUNCH 3

Including eratic lines around the attacker is a good way of showing the force behind the punch.

Focus is set on the characters, with the focal point being the face of the standing figure.

Looking up at a character makes them look powerful.

TRIUMPHANT

The reader takes the viewpoint of the victim, looking up at the victorious assailant.

Hands are used to help tell the story – the limp, weak victim's hand in the foreground contrasts with those of the tightly-gripped victor.

Shot from below, the reader sees the characters in order as the eye goes up the panel, with the strongest of them all reigning at the top.

Don't have all of the characters on the same level, as this not only limits the dominance and power you can show of them, but also the impact of the panel without a focal point.

GROUP SHOT

Pacing

One of the challenges with comic art is to make the reader see what you want them to see, in the order that you want them to see it. Composing your panels with some basic shapes in mind will help with this, as it leads the eye from one panel to another.

The ideal layout for a page, and one that we automatically adopt as we read from left-right, is for a zig-zag that reads from left to right until we reach the end of the page leading to the right, ready for the page turn. Anything within that zig-zag that the eye rests on comfortably is pleasing. If you have a mixture of panel types without any layout or compositional thought put into them, or how they work as a whole on the page, then the reader doesn't know where to look first or next.

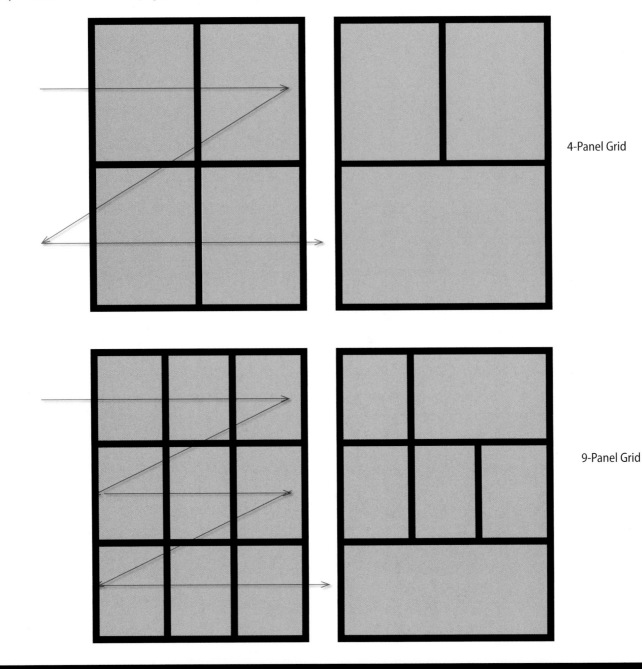

4-Panel Grid

9-Panel Grid

Always plan your page layout and pacing, as well as your actual panel composition, and always have it reading left-right. You can vary the size of the panels as long as they fit the page physically, and the reader can follow them and pick up every part of the story that you're telling. Varying the size of the panels enables you to have peaks in the story, or quieter moments either side of the point of action.

Your comic writer, or the comic house that you are working for, will generally specify the grid size that you need to work to, but the configuration is largely up to you, the artist. Grid sizes can vary from a basic four-panel grid, to three, nine or even twelve panels, which was the grid size for Batman. Vary your pacing within the grid plan to match the story. More, small panels require less detail, while fewer and larger panels require more.

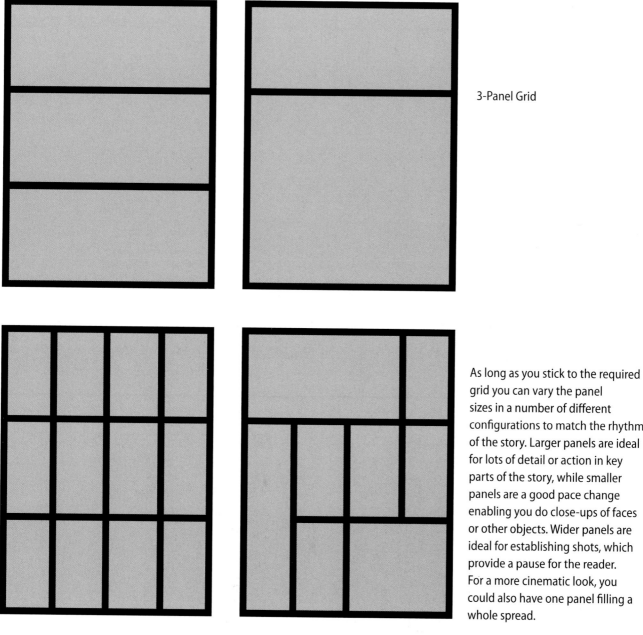

3-Panel Grid

12-Panel Grid

As long as you stick to the required grid you can vary the panel sizes in a number of different configurations to match the rhythm of the story. Larger panels are ideal for lots of detail or action in key parts of the story, while smaller panels are a good pace change enabling you do close-ups of faces or other objects. Wider panels are ideal for establishing shots, which provide a pause for the reader. For a more cinematic look, you could also have one panel filling a whole spread.

Shapes

When the eye looks at an image it scans left to right, and generally settles on a certain point. That point where it rests needs to be your focal point, but you also need to guide the eye to see the rest of the image.

Using 'shapes' within your composition is a good way of making sure that the reader sees what you want them to see in the order you want them to see it. Triangles are always a good shape to aim for, and you can do this by arranging figures, props or background elements so that the eye is pushed up to the top of the triangle.

Emotional impact

If you don't put any thought into the placement of characters and objects in the panel then it has no emotional impact, the reader can't work out what's happening and so becomes disengaged, and the story isn't told. Think about how a panel would look with a bunch of figures just placed in it at the same size, with no thought about the order they appear in or what the part of the story is – it's confusing for the eye to figure out, and we don't know who, or where, we're supposed to look first. Adding these shapes to your art is pleasing to the eye, and helps to guide it around the image.

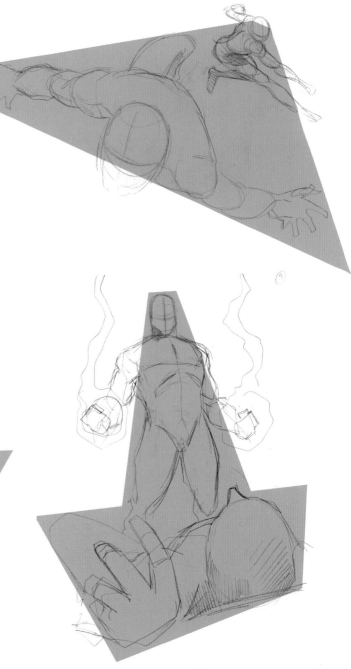

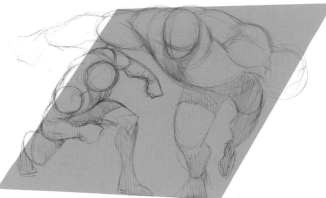

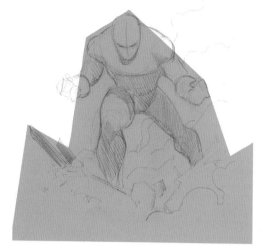

Here are some examples of the kind of shapes you can create with your panel composition. There aren't any hard and fast rules for the kind of shape, just make sure that your panel is arranged in a pleasing, ordered way and that it is easy for the reader to decipher and know what to look at.

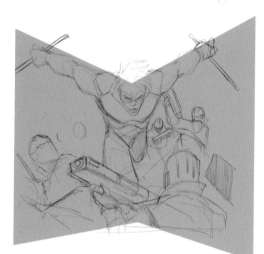

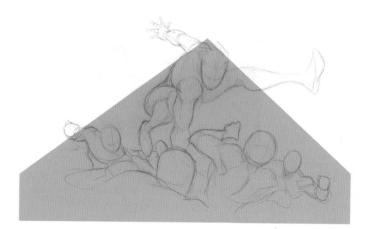

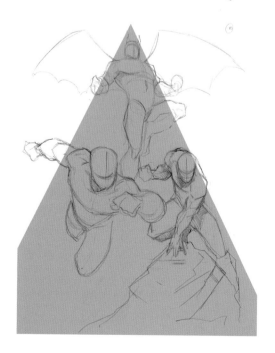

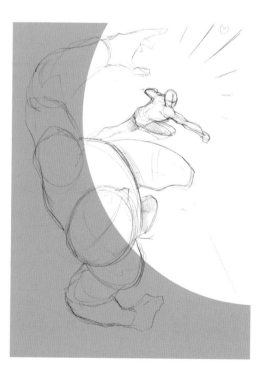

Lighting

Introducing lighting into your piece really brings it to life, and is the moment when your flat artwork becomes three-dimensional. Lighting brings tone and definition – without light and thus shade, an arm or face would be flat. Without lighting, the story you're telling wouldn't be very interesting.

Light enables you to pick out muscle tone, or wrinkles and contortions on the face that hold the shade. It adds interest and detail that would otherwise be missing. It is also a useful storytelling device, so pick your source type and its direction carefully to enhance the story. Backlighting a character from an explosion helps provide a sense of movement, for example, as the figure runs away from the blast. Similarly, showing a character in the blazing headlights of a vehicle has a dramatic, spotlight effect.

Light and colours

The light source can govern the feel of a piece. Soft, yellow-orange light from a fire, for example, would introduce a warm colour scheme to your piece, while the artificial glare from fluorescent lighting would result in predominantly cold whites, greys and blues. Reflected light from snow or ice would bring with it a white colour scheme, and light from a blazing sun on a summer's day would be bright, natural colours. Think about the feel you are aiming for at that point in the story when choosing your lighting.

Having figures in part silhouette, with a clear outline adds an air of mystery and tension.

You can use silhouettes of complete shade for dramatic effect. Having this scene in complete darkness means that it has more impact than if it was an ordinary coloured scene. Pushing foreground objects or figures into silhouette is also a handy device for helping the eye to focus on the key part of the image.

Environmental, unnatural light, such as that from a computer screen, creates different shadow effects as the source comes from below but is indirect.

Faces in shadow can be used to push the personality and darkness of a character.

You don't need much shading for it to be effective. Providing less detail gives the impression of lots of bright light.

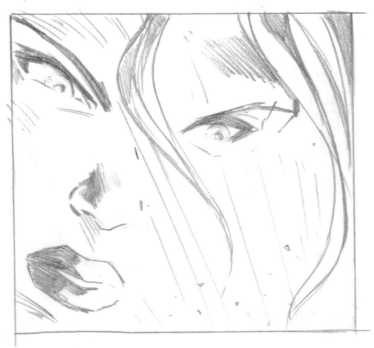

Reading the Script

Comics are about telling stories, and your role as the comic artist is to tell them in a clear, believable, captivating way. A reader should be able look at any panel in the sequence and know straight away what's going on.

Whenever you are creating a panel you have to fulfill some criteria. You have to make sure that the reader knows where they are, what's happening, when it's happening (daytime, night-time, some point in the future or the past) and who's involved. All of this information that you have to graphically portray comes from your script, and you should start thinking about how you're going to represent and render these criteria as you're reading the script.

PAGE FIFTEEN

Abandoned Warehouse, Docklands.

PANEL ONE
Hero enters the abandoned warehouse, half open crates and boxes litter the building.

1. CAPTION (Hero) Figures that a Spider-kind would hide in the dark.

PANEL TWO
As he progresses through the building, Hero steps in something *wet* on the floor.

SFX (Sound Effects) 'Squilch'

PANEL THREE
Stoops to touch the 'goo' and realises, too late, that it's DROOL!!

1. (Hero) Uh-Oh…

PANEL FOUR
Hero's POV as Aracno leaps from above, cackling laughter!

SFX Hahahahahaha

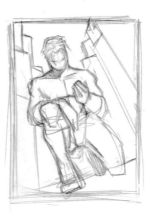

It is up to you where and when in the process you read your script, and your deadlines and time will dictate that. I like to read mine on the bus, or at home the day before I start work on it in the studio. That way, when I get to the studio I know the story, I know what's going to happen and I have a good idea of how I'm going to do it. You may want to start reading the script at your drawing board and get going straight away, but wherever and whenever you decide to it, this initial read-through and visualization is a really critical part of the process.

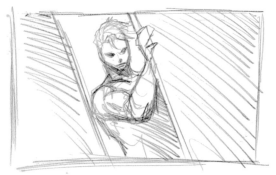

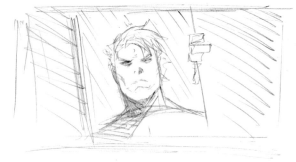

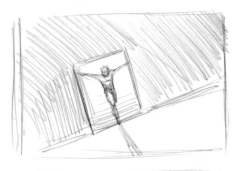

Read the script and doodle some quick ideas as they come into your mind. Don't try to censor yourself, and use this opportunity to play around with the camera angles and composition of the panel.

You need to use this rough stage to start working out how you're going to show something in the story, so that you have a pretty clear idea of what it is you're going to draw once you get going.

One thing to always bear in mind when you're drawing comics is that you have to present things so that the reader sees them in the order that you want them to, and that they don't miss anything. You need to identify exactly what needs to go where in the panel, and you need to make sure that all of the panels are paced correctly when you put them together on the page.

Rough out what a key action point looks like from different angles in order to help you to choose the most impactful one.

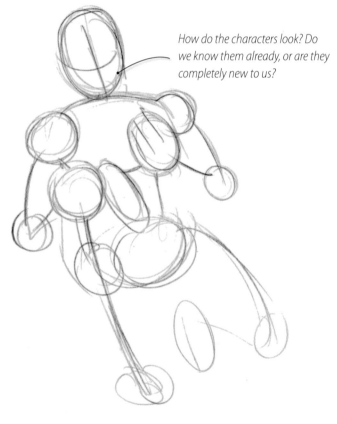

How do the characters look? Do we know them already, or are they completely new to us?

The initial read-through of the script makes you immediately visualize the panels, and problem panels will become apparent, as well as the strong, focal panels. You should come away from this initial read-through knowing which panel is going to be the main one, have a pretty good idea of what it's going to look like and what it's going to tell the reader. Having this as your central starting point will enable you to correctly pace the panels leading up to that one and after it.

When thinking about your pacing you need to think about the actual panel size on the page, and the amount of information that each panel conveys. You don't want a whole page of close-up profiles of people's heads, for example, because it just won't work visually and won't be captivating. Neither would you really want a whole page of establishing shots, or wide-angle scenes. You need to make sure that the pacing is engaging and informative for the reader. If you've had a series of intense action, think about pulling back for a calmer wide shot or, similarly, if you've had a lot of dialogue, have an establishing shot just to give a change of pace and keep the reader interested.

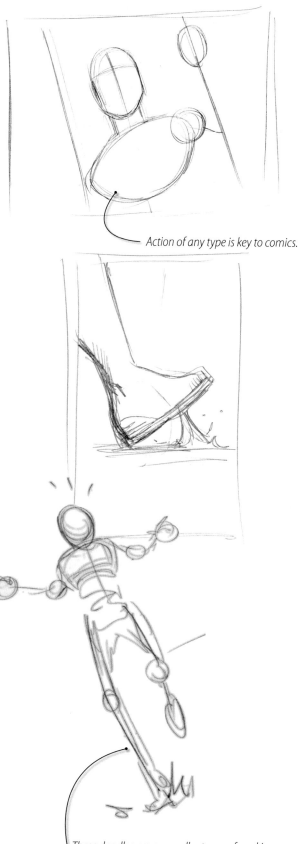

Action of any type is key to comics.

Working out the best camera angle is often about trial and error.

These doodles are an excellent way of working out the visuals of the script.

Panelling

You have worked up your thumbnails and are happy with how they're working, so now's the time to take them to the next level and work up some panel roughs. You should be working at A6-size with your page shapes, and should now be scribbling a little more detail than just stick figures.

The purpose of this stage is check that your panel composition works, before you spend too much time working up your more finished drawings only to discover that it's not quite right and have to start again. You also need to use this stage to ensure that the main points of the story are being hit, so keep your script to hand and refer back to it often.

If you're using photo reference for your pieces then sketch your panels up straight away to make sure that you have all of the angles right, or flesh out the drawing in more detail on A4 (equivalent to letter size paper). Working without photo reference is more instinctive and focuses more on the composition, whereas photo reference requires you to portray everything accurately so you need to spend more time perfecting the detail. Using photo reference is useful, and sometimes essential, but it does limit your instinctive creativity, so try not to use it all of the time.

First Drawings

Your role as the comic artist is to tell the story, and this planning and roughing-out stage is an important part of the process. If you don't plan the story properly and take the time to read the script and really get to know the characters, then your storytelling is going to suffer as a result.

It makes logical sense to create your panels in the order in which they fall in the script. When you are a bit more experienced (and free of tight deadlines) you can tackle the panels in whatever order you prefer. Starting with the peak of the story can really help to inspire energy in your work, and can help with the build up to and down from that point, but you have to be absolutely confident in your work and abilities to make this way of working really successful.

Whatever order you use to create the panels, don't ever leave the nasty ones until last! It might be appealing to work that way, or you may find a part in the script that really sets your imagination on fire and you want to start with that one, but the difficult areas are not going to go away if you ignore them. If anything, these are the ones that you should spend the most amount of time on to ensure that they don't turn out badly.

If you do come across a tricky panel, there are a couple of things you can do to help tackle it. Create lots of thumbnails to get the composition and angles working; play with the camera angles and shapes in the piece to achieve maximum impact; go and look at photo references for the subjects, or look at how other artists have tackled this kind of problem.

Whatever you do, don't progress to finished pencils until you know exactly what you're creating, and don't just sit there at your board stewing over it, as this will generally result in your creativity 'hitting a wall'. If this happens, take a break and go and do something else entirely, or start working on a different area of the story – sometimes just getting inspired by another area is enough to fire up the imagination again.

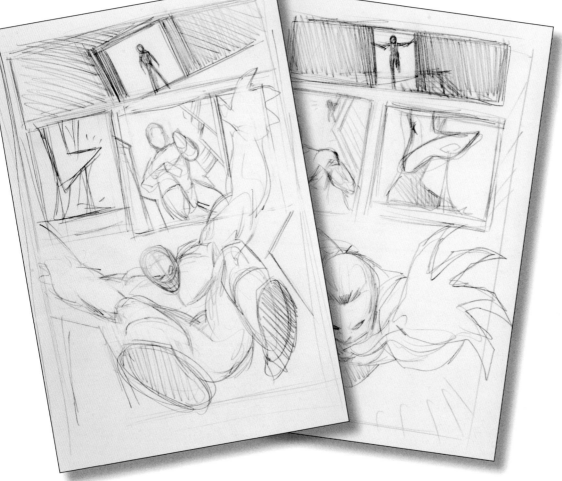

You will come up against many difficult areas in your work, and it can be a challenge to keep everything looking different and fresh. It is important to know yourself and the way in which you work best, and play to that. If you are at your most creative or productive in the middle of the night, then do your work at that time rather than trying to force yourself to be creative at other times that just don't suit you. Give yourself the best chance to create your artwork, and enjoy it – even the difficult bits!

On the Lightbox

A lightbox is a really handy bit of kit for a comic artist. You can manage without one when you're just starting out, but it's a good idea to get one as soon as you can. This makes your work from initial thumbnails through to roughs and final board one creative process, and means you can pick the bits you want to keep at each stage.

Keep working on ordinary A4 paper (equivalent to letter size paper) until you're happy with the way the panels are progressing. Try to create the panels at the full size now, rather than thumbnails or scaled-down versions, otherwise you won't really get an accurate feel for scale and perspective.

Once you're 100% happy with how everything's looking and are confident that you know exactly what your end piece is going to look like and can render it accurately, then you can move onto the lightbox and art board.

Take your piece onto the lightbox to pick out the final lines, but don't let yourself just trace the piece underneath – use this as another developmental stage, adding details and tweaking the lines as necessary. Don't stay on the lightbox longer than you need to – apart from getting sweaty hands, you won't be able to be as freely creative as you can be when working off it.

Make sure that you turn the lightbox off frequently so that you can see how the lines you're drawing are looking, and make any adjustments to areas that you need to.

As we have learned, to achieve dynamic action in comics you need to go for maximum impact in every panel you create. Whether that impact comes through action, an establishing shot, a close-up or two conversing figures, you need to represent it accurately, realisitically and so that it grabs the reader's interest and holds it. You are more than likely to come across a flying scene in any comic, and you need to be able to draw that clearly and impactfully, and really make it jump off the page. The trick with any comic art is to choose the focal point of the panel, and create everything else around that, providing sufficient information in the rest of the image to tell the story yet not distract the reader's eye away from what you want them to see and focus on. Make sure that you show enough information that we know who it is, what they're doing and where they're doing it, and nothing more.

1 Start by creating your thumbnail image to work up the basic composition. The focal point in this image is at the very centre – that is what the reader is going to be drawn to and look at first. Think of a giant 'X' across the image, with the focal point right in the join of the two lines. Create as many thumbnails as you need to be happy with the composition and have a clear idea what the end piece is going to look like.

2 Start working in full size, on rough paper now. Create your stick figure, referring back to your thumbnail as necessary. Place the joint circles carefully, and think about what parts of the body will be visible, where you will see them and what shape they will be.

3 Start adding in your cylindrical shapes to give your figure some form and three dimension. Keep your pencil lines loose and fluid at this stage.

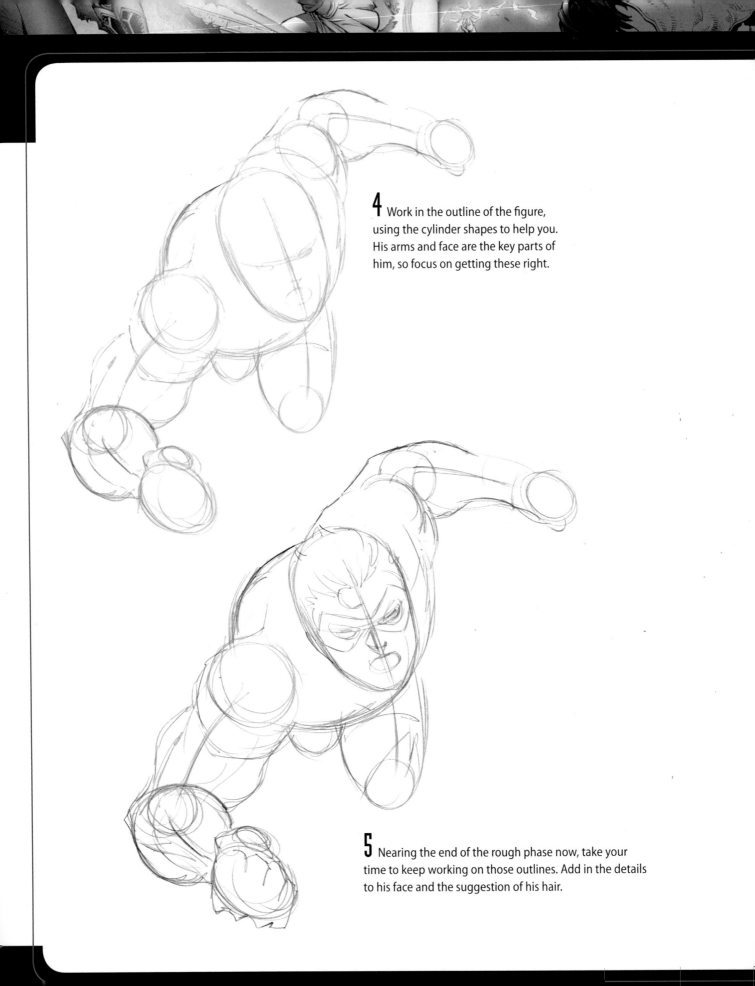

4 Work in the outline of the figure, using the cylinder shapes to help you. His arms and face are the key parts of him, so focus on getting these right.

5 Nearing the end of the rough phase now, take your time to keep working on those outlines. Add in the details to his face and the suggestion of his hair.

6 Add some more definition to his hair – sweep it back to accentuate his forward movement. Work in some finer details to his face, thinking about what his facial expression is likely to be.

All of the foreshortening in this image helps to create a real sense of travel.

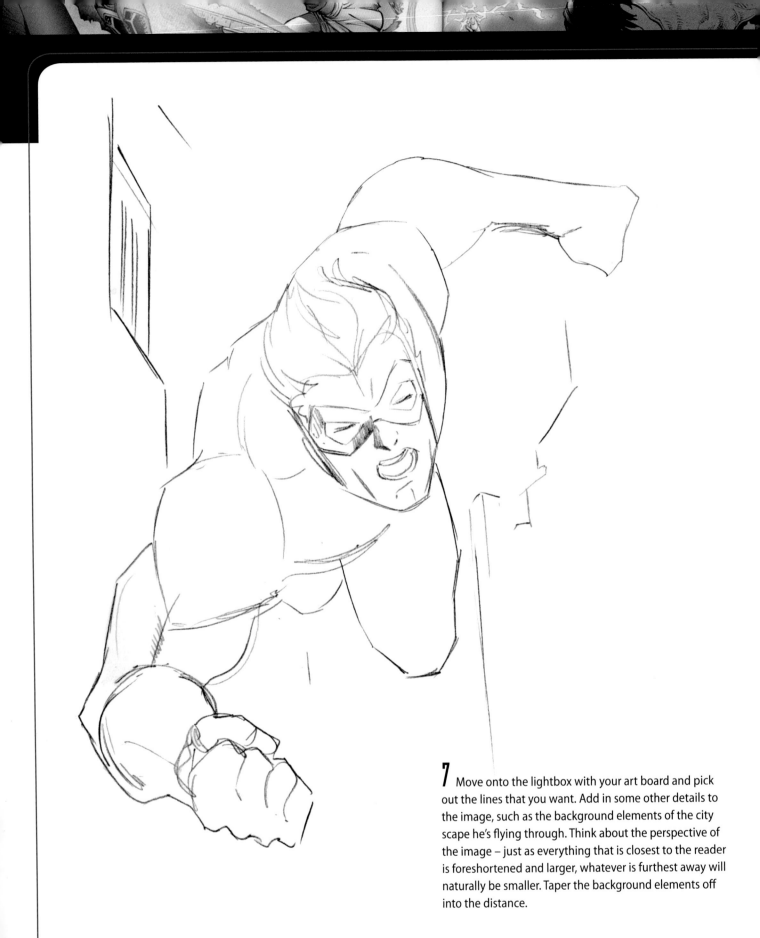

7 Move onto the lightbox with your art board and pick out the lines that you want. Add in some other details to the image, such as the background elements of the city scape he's flying through. Think about the perspective of the image – just as everything that is closest to the reader is foreshortened and larger, whatever is furthest away will naturally be smaller. Taper the background elements off into the distance.

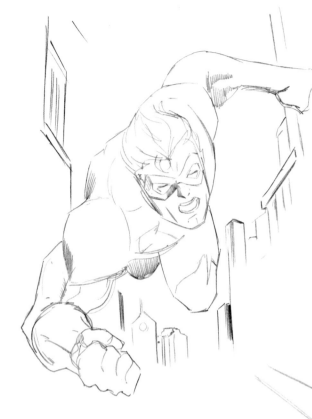

8 Begin working in some tone to the arms and legs. Add in some more detail to the backrgound elements, but remember that you don't want to add so much that it distracts the reader's eye from the focal point. You would be surprised how little definition the human eye needs to be able to recognize what something is.

9 Use your hatching marks to add in shading to the background elements. Continue working in definition to the muscles of the arms and torso.

10 How far you take the pencil stage before you ink and scan it into your computer to start the colour work is entirely up to you. My personal preference is to get the piece to completely finished pencils so that I know what it's going to look like. I also prefer to work in all of the detail elements in pencil, rather than doing it in inks or digitally, but you have to decide what works for you.

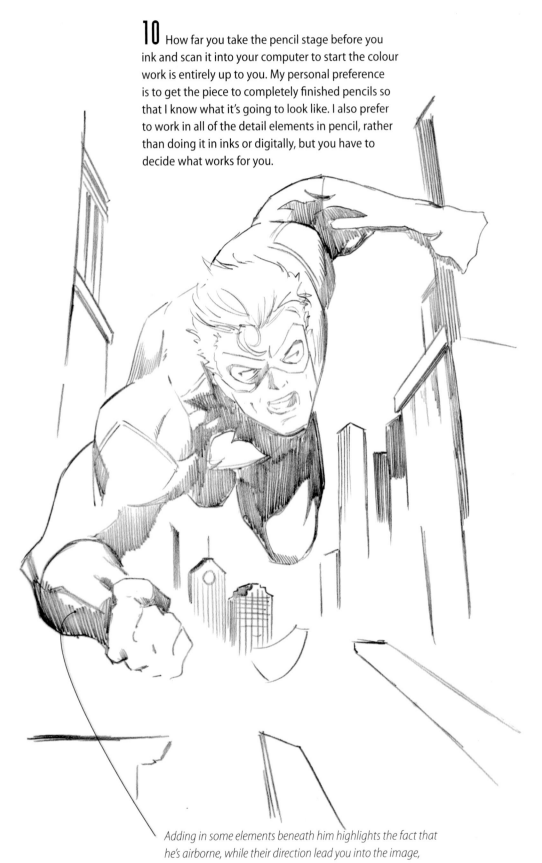

Adding in some elements beneath him highlights the fact that he's airborne, while their direction lead you into the image, acting almost as speedlines.

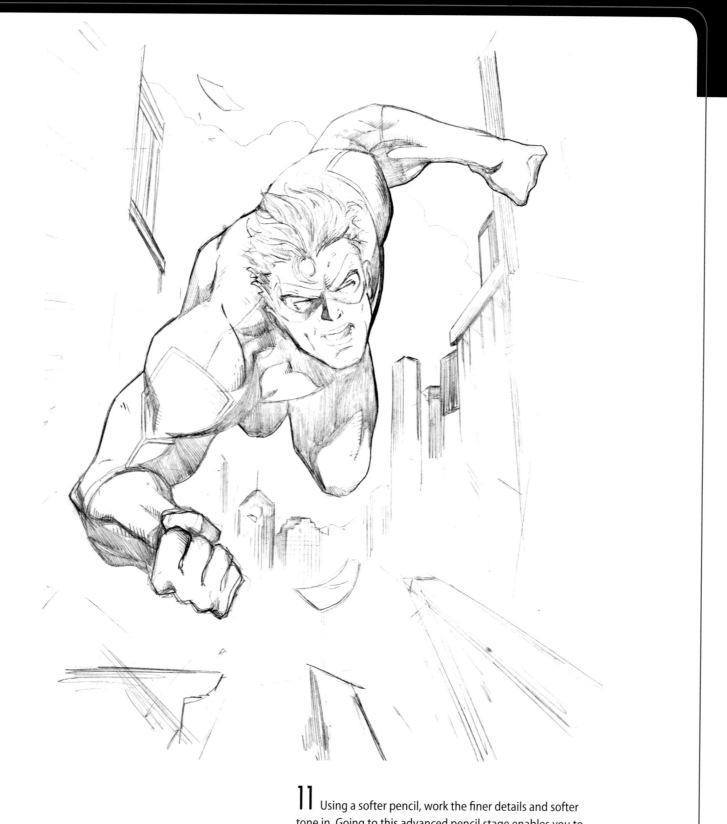

11 Using a softer pencil, work the finer details and softer tone in. Going to this advanced pencil stage enables you to introduce more detail to areas such as the costume, hair and face, but be careful not to spend too long working at this stage, especially if you're on a deadline.

12 Now at the inking stage, all that detailed pencil work means that you can just work over the lines with your pens and brushes. Inking takes a lot of practise and experience to get right, and is beyond the realms of this book!

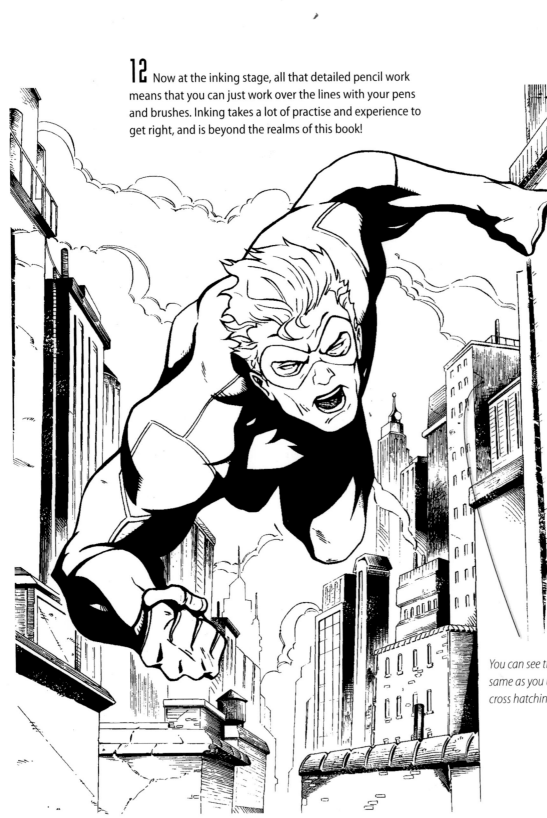

You can see that many of marks are the same as you use with a pencil – hatching, cross hatching and blocks of tone.

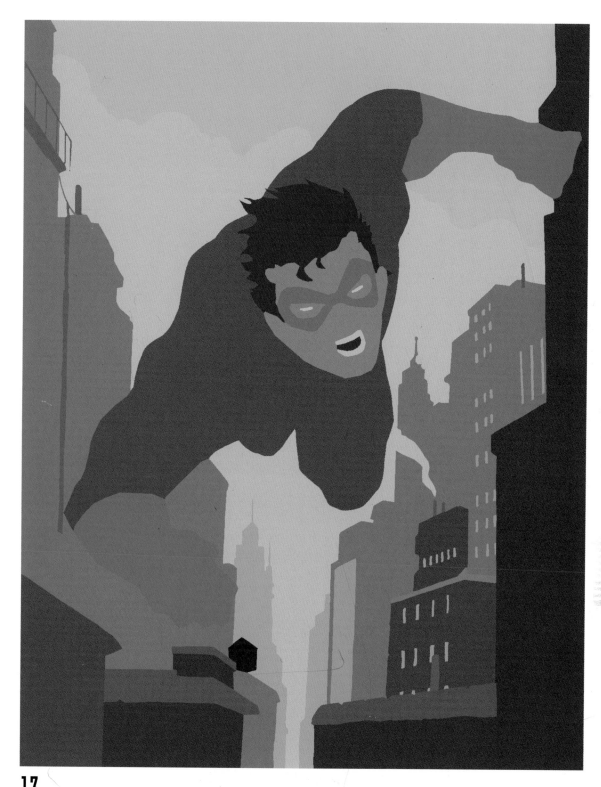

13 Having scanned the image into the computer it's now time to start working digitally. Using Photoshop, select the area blocks of the image using the marquee tool, and then fill with the colour of your choice. It is a good idea to add each colour to its own layer, and remember not to have bright, distracting colours in the background.

14 Once you've picked the colours for your character you need to start putting in the basic flat areas. This is known as 'flatting', and many pro colourists hire someone to do this bit. It may help to work in the colours you want the character to be, but you can really use any colours at this stage, as long as you can select each element separately to make alterations.

The background (city) and foreground (character) elements should be on a separate layer so that you can alter them individually without affecting the other. If you really want to have control you may want to make several layers for the elements, i.e. the character's flesh, hair, costume, gloves etc all on separate layers.

14

15

15 Now you've got the colours down and are happy with the overall look of your image you can start adding the form. This stage is known as 'Modelling', as you're giving the character form and shape. This is the time where you'll want to select a light source and start adding shadow and highlights.

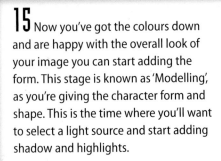

When that's done, try adding a colour layer over all or most of your page; use a colour that you think will give atmosphere to the image – a warm orange or a cool purple are good starting points. Make this layer an overlay or multiply it and reduce opacity just so that you get a consistent hue to the image.

Group fighting scenes should look like mayhem – but ordered mayhem. They should be full of action, and everybody should be doing something and interacting. The key thing is that, through all of this chaos, the reader should be able to work out exactly what's going on. In a scene like this where there are lots of different characters doing lots of different things it is important to try to make everyone look as distinctive as possible. This can be done through clothing, hair or sheer size, and it helps the eye to distinguish what's happening and to whom, and to generally unpick the action in the scene. Group fight scenes have a very clear focus, and that is purely on the characters and the action. You shouldn't need to augment the story with any background or environment details, leaving the characters and what they're doing to tell the whole story.

1 Begin with your compositional thumbnail, remembering to pin-point the focus in the panel and building around that. Try creating one character first, then adding in more characters one-by-one until you're happy with the number in the panel and the action that's taking place. The shape of this composition (see p. 90) is triangular, designed to push your eye upwards.

2 Varying the size of the characters provides the depth in the image, rather than using any image recession. This means that the foreground characters 'pop' out of the image, and the smaller ones in the background look active as they buzz around getting involved. Be creative with the body parts that are visible – adding an expressive hand means that we can see who the central figure is punching, without having the whole body or even the face. Don't be afraid to play around with the options – you should always try something if you can, and that's exactly what these early stages are about.

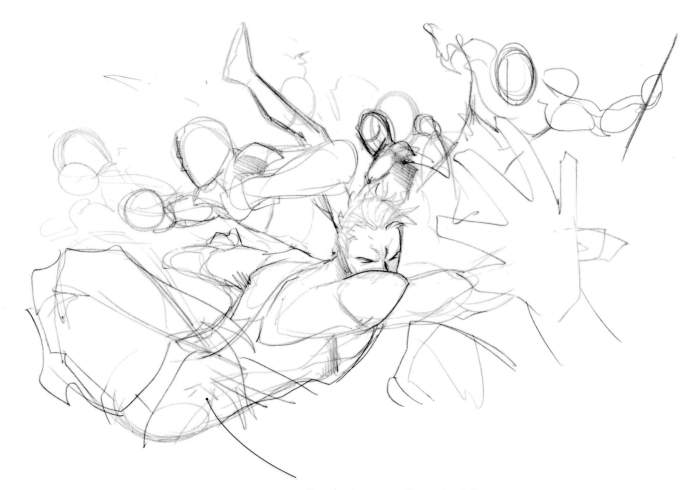

Keep the character outlines and stick figures really rough while you're just working out the character placement and action. Remember the spine is never straight – it has to support whatever the body is doing.

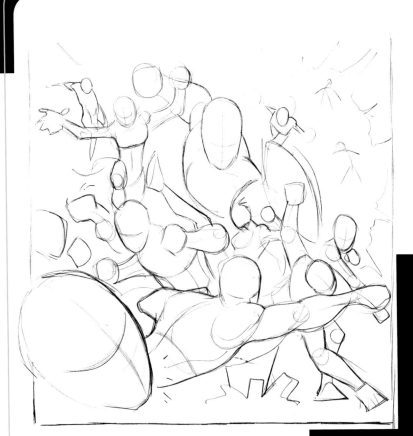

3 I decided that the image had more impact with the punched face popping out of the frame at the reader. Once you're happy with the characters in the scene, tidy up your lines and outlines ready for the lightbox.

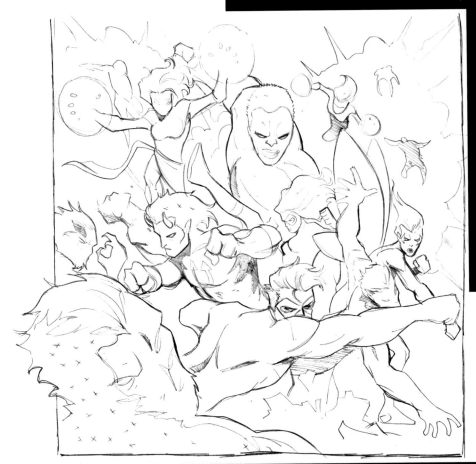

4 Pick out your lines on the lightbox, before moving back onto the drawing board and adding in those all-important details to the figures. Have the most detail on the characters in the foreground that we see first, rather than spending hours working in the detail to a background figure we can't even see.

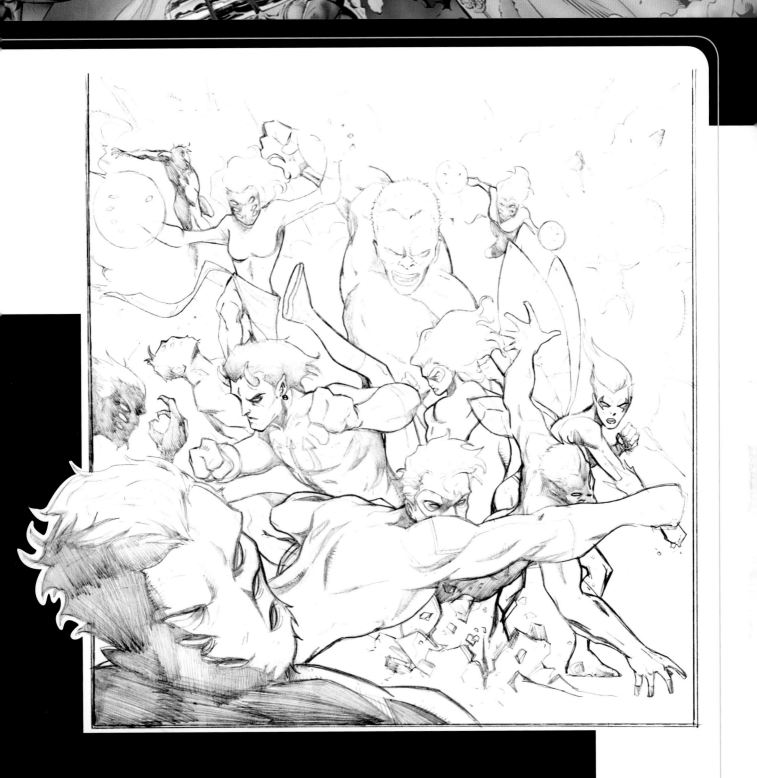

5 Adding lighting and tone to the piece really brings it alive. Think carefully about the best areas to introduce shade to, and work on one figure at a time rather than trying to tackle the scene as a whole.

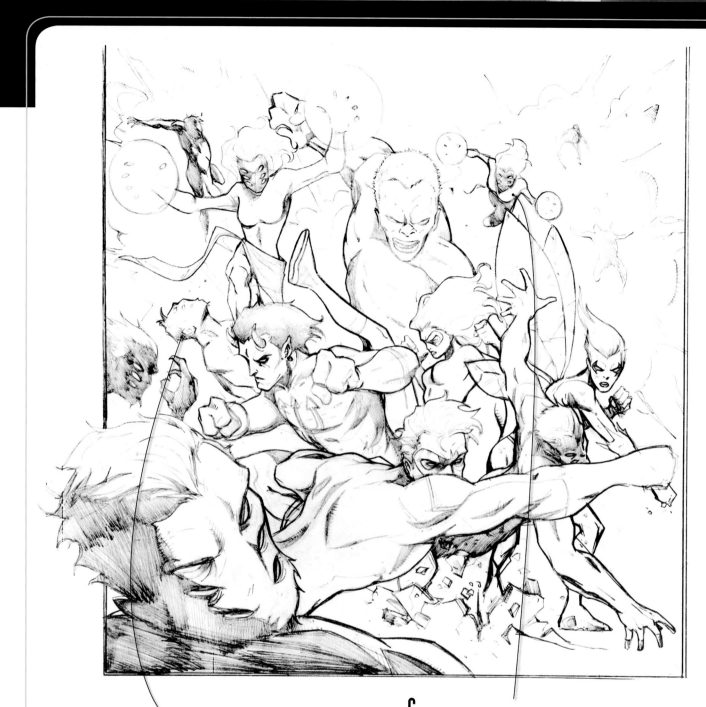

Use a softer pencil to refine the shading and make it a bit more subtle.

6 Use this last stage before inking to check that you're happy with everything in the piece – this is your last chance to change it! Check you're happy with the level of detail in the background figure and that everyone in the shot has a purpose and is doing something. Your eye should be sucked into the whole action and fully absorbed looking around at everything that's going on.

7 Having gone to such detail with the pencil stages means that the inks look just as we want them. When you're working with your own inker, or even just doing your own work, you will discover what level of pencil detail works best.

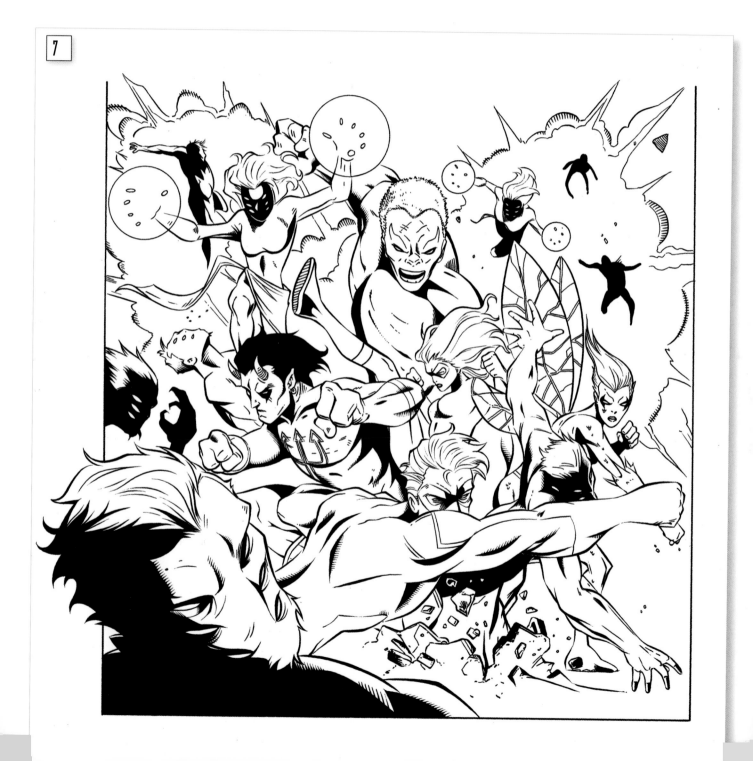

8 Scan your inked piece into Photoshop and start working on the colour. Choose your colour scheme for your characters and the image as a whole, and start selection the colour blocks using the marquee tool. Remember that it's good to have a new layer for each colour so that you can check they're working together.

9 Finish flatting in all of your basic colours, and then start working on your modelling. Play around with all of the different brushes, colours and finishes available in Photoshop. It is a good idea to have each of the characters on a different level for this piece. Or, if that gets excessive, separate out the fore- and background characters onto different layers. However you work, it's important that you can edit areas without interfering with other parts of the piece, and being able to switch areas on and off comes in really handy.

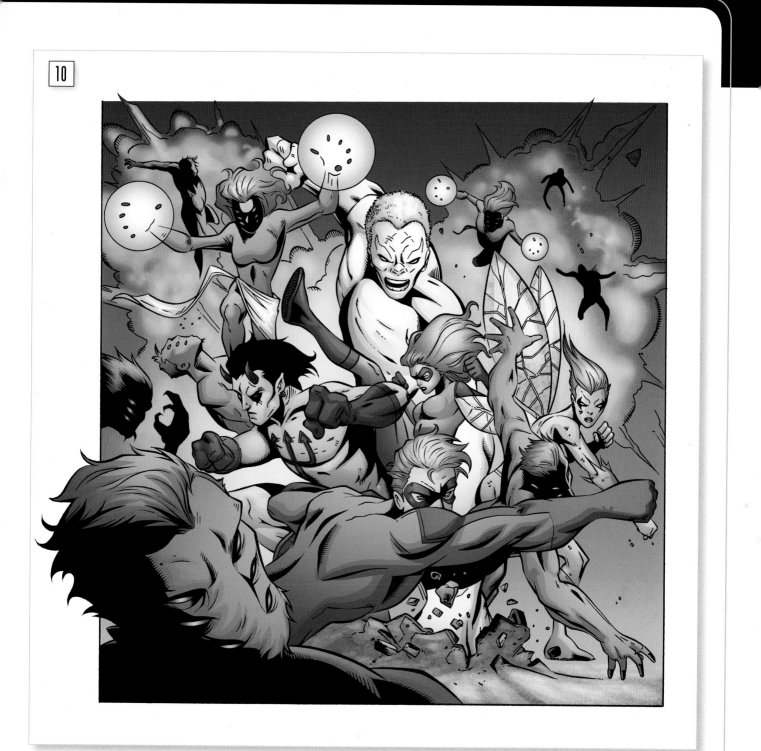

10 Your explosion and background areas should definitely be on a separate layer so that you can perfect them before laying the characters over the top. Creating explosions gives you the opportunity to do some really interesting lighting, putting some of the darkers characters into the shade while the heroes are highlighted in the blast.

11 Now's the time to add those finishing touches to the piece. Use the zoom tool to its maximum advantage to get really into the detail of the piece.

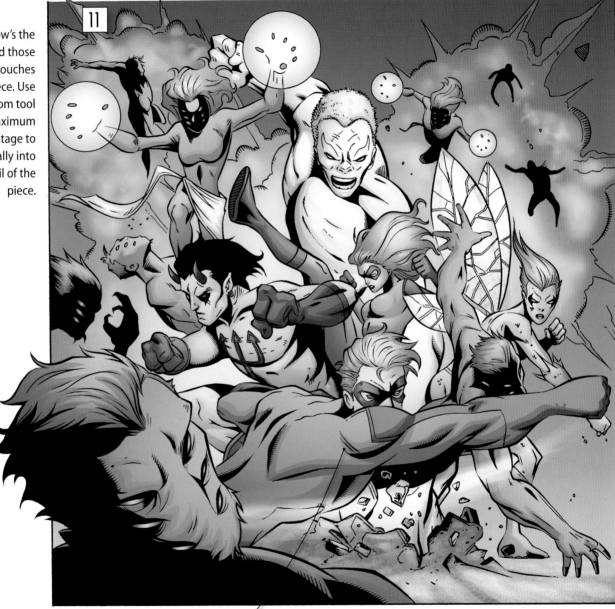

Adding in this subtle speedline completes the piece, and really highlights the power and energy of the punch that's just landed on the bad guy coming out of the panel.

Here you have it. Absolute fight scene chaos, yet ordered and captivating. The action in the image comes from the sheer number of characters present doing different things, as well as the dynamic punch that is taking place centre stage.

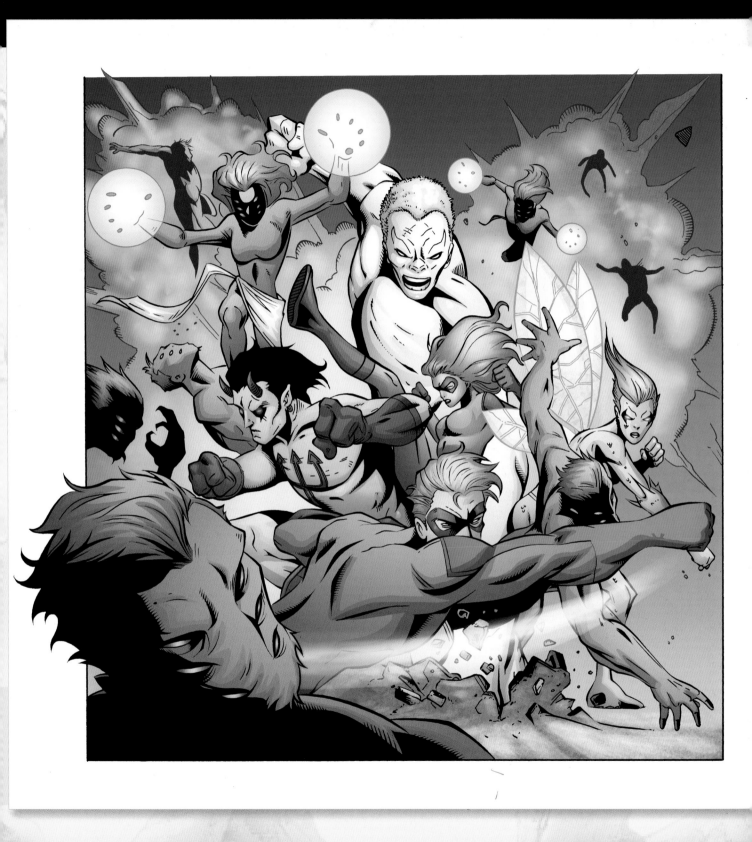

Acknowledgments

Thanks to Emily whose name should be on the cover too.

Jock (Simmo!) for all the support, thoughts
and laughs throughout! VERY NICE!

Special Thanks
Mia, Freya, Pru, Stacy and Kim. Matt Smith at 2000AD.
Scott Peterson, Mike Siglain, Mike Marts, Hank Kanalz
and Jack Mahan at DC Comics.

Walden Wong (www.waldenwong.com)

David Baron (www.firedice.com)

Stephen Baskerville
(http://baskerville.mysite.wanadoo-members.co.uk/)

Picture credits:
Flying Project – cover and fight colours: David Baron.
Flying Project – inks: Stephen Baskerville.
Fight Project – inks: Walden Wong.
GIGGS cover (p. 33) – colours: David Baron.